SHEFFIELD IN 50 BUILDINGS

IAN D. ROTHERHAM

AMBERLEY

First published 2018

Amberley Publishing, The Hill, Stroud
Gloucestershire GL5 4EP

www.amberley-books.com

British Library Cataloguing in Publication Data.
A catalogue record for this book is available from the British Library.

ISBN 978 1 4456 6334 0 (print)
ISBN 978 1 4456 6335 7 (ebook)

Origination by Amberley Publishing.
Printed in Great Britain.

Contents

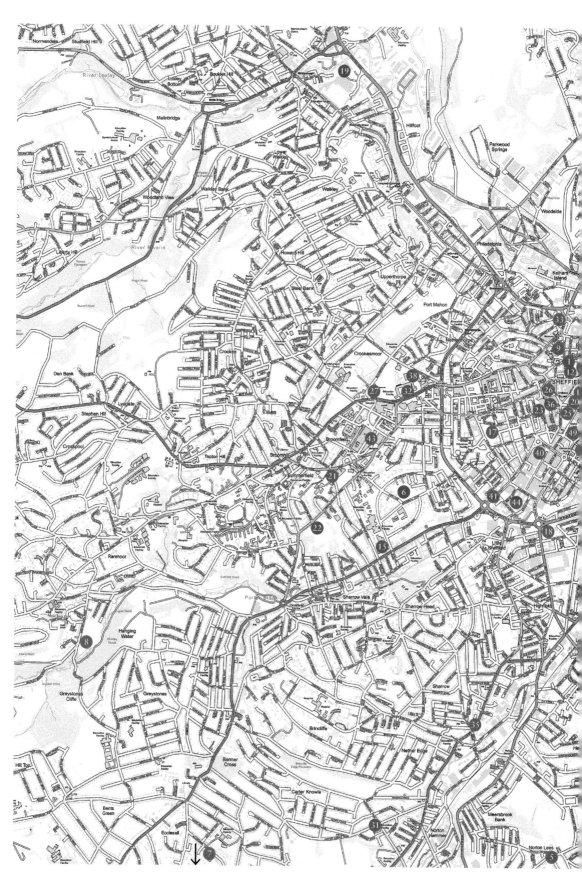

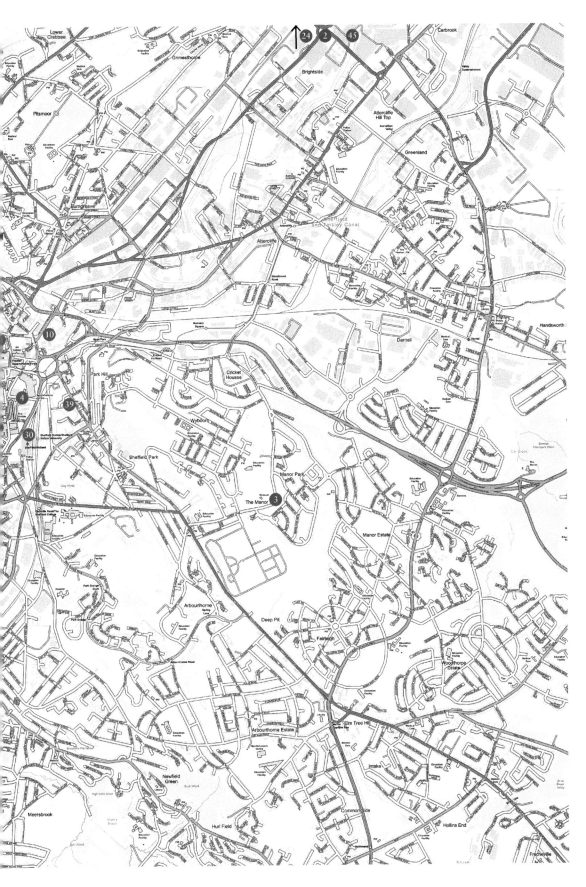

Key

1. Sheffield Cathedral, Church Street
2. Carbrook Hall, Attercliffe
3. Sheffield Manor Lodge, Manor Lane
4. The Old Queens Head, or the Hall-in-the-Ponds
5. Bishops' House, Meersbrook Park, Norton Lees Lane
6. Broom Hall, Broomhall Road
7. Abbeydale Industrial Hamlet or Tyzacks' Works, Abbeydale Road
8. Shepherd Wheel, Bingham Park, Endcliffe
9. Paradise Square
10. Victoria Quays, Furnival Road
11. The (Old) Old Town Hall
12. The Cutlers' Hall, Church Street
13. Venture House, Arundel Street
14. Butcher's Works, Arundel Street
15. Collegiate Hall, Ecclesall Road
16. The Cathedral Church of St Marie (Roman Catholic), Norfolk Street
17. Devonshire Green, Devonshire Street
18. St Mary's Church, Bramall Lane
19. Hillsborough Barracks, Langsett Road
20. Upper Chapel, Norfolk Street
21. King Edward VII School or Wesley College, Glossop Road
22. Sheffield Botanical Gardens
23. The Water Works Company Building, Division Street
24. River Don Works, Brightside Lane
25. The (New) Old Town Hall
26. Former Central School and Firth College (Now Leopold Square), Leopold Street
27. The Mappin Art Gallery and Weston Park Museum, Western Bank
28. The Lyceum Theatre, Arundel Gate
29. Victoria Hall, Norfolk Street
30. The Midland Station, Sheaf Square
31. Carterknowle Junior School
32. Sheffield University Firth Hall, Western Bank
33. Mayfair Court, Former Common Lodging House, West Bar
34. Former Sheffield Telegraph and Star Building, High Street
35. Abbeydale Picture Palace (Abbeydale Cinema), Abbeydale Road
36. The City Hall
37. Graves Art Gallery and Central Library
38. The Arts Tower, Sheffield University, Weston Bank / Bolsover Street
39. Park Hill High-Rise/Hyde Park
40. Debenhams, The Moor/Charter Row
41. Electricity Substation, Moore Street
42. The Crucible Theatre, Arundel Gate
43. The Royal Hallamshire Hospital, Glossop Road
44. The Manpower Services Commission Building, Moorfoot
45. Meadowhall Shopping Centre, Meadowhall Way
46. The Owen Building, Sheffield Hallam University, Pond Street
47. The National Centre for Popular Music aka Sheffield Hallam University Students' Union Building
48. The Millennium Galleries and Winter Gardens, Arundel Street
49. The Cheese Grater, Charles Street
50. St Paul's Tower, Arundel Gate

Introduction

Sheffield is one of England's major cities and yet retains the feel of a parochial town. Said to be the coming together of numerous villages and hamlets, and set on a framework of seven hills and seven rivers, the city lacks the grandiose, major buildings of say Leeds or Manchester. Furthermore, Sheffield centre was badly damaged during the Blitz in 1940, and the local joke was that where the Germans failed to destroy, the 1950s and 1960s planners succeeded. The truth in this was that much of the old medieval or early industrial town was swept away by a tide of largely indifferent modern architecture. Writing in 1959 on the West Riding of Yorkshire, Sir Nicholas Pevsner, author of the definitive series on British architectural history, felt the pre-war architecture was 'a miserable disappointment, the layout of the centre confused, the buildings – certainly before the late nineteenth century – of no distinction'. Architectural critic Ian Nairn loved the Sheffield markets but thought the old buildings to be 'something of a joke' and 'in style after style, there is the demure and the second rate'.

However, Pevsner did note the dramatic influence and impact of Sheffield's environs, writing that 'None of the big cities of England has such majestic surroundings'. The hills give a richly textured backdrop to the city and the valleys encourage local identity above a greater corporate awareness. Sometimes this is reflected in the architecture too. Furthermore, heavy industry developed and grew in the eastern lowlands and the prevailing westerly winds took the gross air pollution away from the western suburbs. Along with a separation of buildings and architecture between the town centre and the residential suburbs, Sheffield has a notable split even today: between the affluent western suburbs on the Pennine foothills, and the poorer eastern and lowland communities. The other obvious trend is between developments on the sunnier south-facing slopes and the shadier, bleaker, north-facing ones. The first tends to have grand mansions and upmarket villas, and the latter has the rest!

Sheffield expanded rapidly from the 1600s to the early 1900s as industry and population grew and the small parochial town became a powerhouse for the global steel industry. Open countryside and villages were swept away to be subsumed by sprawling conurbation. However, Sheffield differs from most big cities in that the topography restricted development to suitable lands and allowed green spaces like woods to remain into the very heart of the city. With wealth came grand houses, parks, and both industrial and civic buildings. As with all cities there were slums, then slum clearance, but these were followed by the Blitz and post-war reconstruction. In recent years there has been a tension between the city centre and the post-industrial Don Valley with Meadowhall and other retail and entertainment faculties. Nevertheless, from the difficult times as described, Sheffield centre has re-emerged with new-found purpose and a vision to be a truly 'European-style' city of walkways, plazas, squares and street culture. Arriving at the Midland station to walk up and through galleries and gardens into the centre, visitors are pleasantly surprised by the modern and welcoming city. This volume concentrates on fifty buildings in and around the city centre but could easily have covered more, and so this is merely a sample – a selection of what Sheffield has to offer.

The 50 Buildings

1. Sheffield Cathedral (Parish Church of St Peter and St Paul), Church Street

In 1914, Sheffield's modest, medieval parish church became a cathedral of a new Anglican diocese. This was never a building of the grand medieval cathedral style, and despite attempts to render it more 'cathedral-like', it remains a somewhat eclectic mix of styles and aspirations. The modern building probably incorporates fragments of the post-Domesday structure, which was built around the same time as Sheffield Castle – 1116 – by lord of the manor, William de Lovetot. This early church was probably destroyed around 1266 and a new building was consecrated in the 1280s only to be rebuilt in 1430. There were further

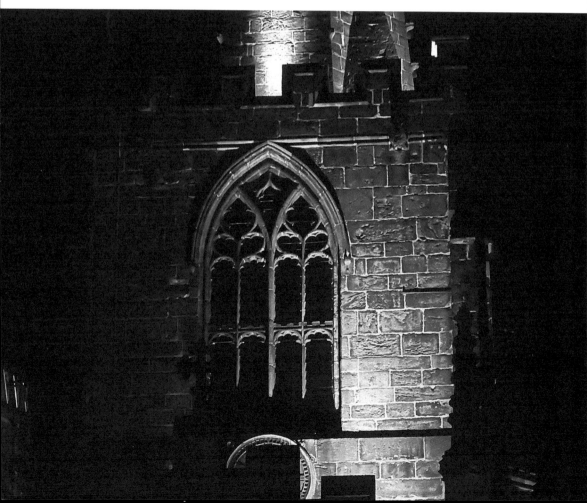

Opposite, right and below: Sheffield Cathedral.

additions such as by the 4th Earl Shrewsbury around 1520. However, by the late 1700s, much of the building was considered to be in a ruinous state and architect John Carr was engaged to deal with the situation; the result being a convincing Gothic feel to the emerging structures. Further works were undertaken by Carr's successors throughout the later 1700s and the 1800s, until by the late nineteenth century, a major restoration took place.

In 1919, eminent architect Sir Charles Nicholson was commissioned to carry out a significant transformation into a building considered fitting for a major cathedral. Nevertheless, shortage of money meant the plans were put on hold until 1937, when Nicholson embarked on a more radical solution. However, this again was suspended due to the outbreak of war in 1939.

By the 1960s the church had received a makeover and additions, and finally the implementation of modifications of earlier designs by Arthur Bailey. Plans by Dykes-Bower and Pace never came to fruition as both resigned due to constraints of cost. The new buildings were finally dedicated in 1966, but for me the overall result is something of a muddle. I confess to quite liking the 1936 design of Nicholson, which, though perhaps conservative, would have produced an integral church design worthy of a cathedral. I still find that the modern twentieth-century additions jar with the Victorian and earlier structures. The interior of the cathedral has important and historic features, such as the Shrewsbury Monuments from the mid- and late 1500s, early marble work by Sir Francis Chantrey of Norton, and fine stained glass.

2. Carbrook Hall, Attercliffe

Carbrook Hall in the Lower Don Valley, west of Attercliffe Common, was until recently Sheffield's most haunted public house. Rumour has it that it may soon become a chain coffee shop. Located in the Attercliffe district east of Sheffield town centre, the original building (from around 1176) was the property of the Blunt family. Following rebuilding in 1462, it was acquired by Thomas Bright (Lord of the Manor of Ecclesall). His descendant, John Bright, was active for Parliament during the English Civil War, with the house being used as a Roundhead meeting place during Sheffield Castle siege.

The present building is largely the stone-built wing that was added around 1620 to a much older property, the family seat of the Brights, which was mostly demolished in the 1800s. Stephen Bright became Bailiff of Hallamshire in 1622 and amassed considerable wealth. The building includes the best pre-classical seventeenth-century interiors in Sheffield, with richly decorated oak panelling, a carved overmantel and beautiful plaster ceiling. From the designs involved in the ceilings, for example, it is believed the craftsmen undertaking the work also engaged in projects at nearby Bolsover Castle in north Derbyshire. What survives today is Grade II listed.

When you go through the door and into the main room or dining area it is like being transported back hundreds of years. Carbrook Hall has stood witness to many of Sheffield's historic events. From its early days in green open countryside the place has survived the English Civil War, the Industrial Revolution, the 1864 great Sheffield flood (when over 240 people lost their lives in England's worst peacetime disaster), and two world wars. The latter included the Blitz of Sheffield in 1940, where the main target was the steel factories that surround the site. This was followed by the slum clearance of Attercliffe in the 1950s,

Above: Carbrook Hall.

Right: Carbook Hall's 'ghost'.

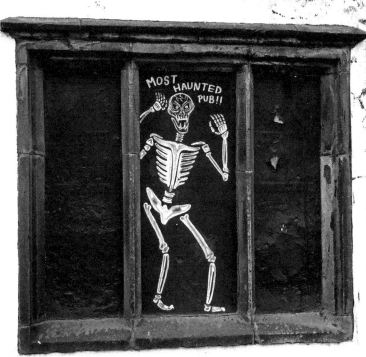

1960s, and 1970s, when nearly all the local residents were moved away from the old houses to more modern council estates. By the 1980s, almost all the mass, labour-intensive, steel industry had closed. Today the building is in the heartland of Sheffield's retail and leisure centre, though still overshadowed by massive steel factories.

3. Sheffield Manor Lodge, Manor Lane

The Lord of Hallamshire, Thomas de Furnival, was granted the right of free warren by the Crown in 1296. This allowed him to enclose Sheffield Manor Park and to hunt within it. In 1637, the park was estimated to be 2,461 acres in extent. The main structure that remains, and one of Sheffield's oldest extant properties, is the Manor Lodge, the late medieval hunting lodge. This building has been partially restored and was lovingly cared for by the City Museums Department, and now by a local charitable group and dedicated volunteers. There are substantial ruins and buildings remaining, but the original house was considerably larger than is visible today. As Sheffield Castle became less favoured as a residence, the lord transferred largely to the Manor Lodge, where there was considerable rebuilding to make it a place to live rather than merely a hunting lodge. This included work on the long gallery and to the tower called Wolsey's Tower, which was named after one of its most famous visitors: Archbishop Thomas Wolsey, resident during 1529 after his falling from favour with Henry VIII. Wolsey died of natural causes in 1530 on his way back to London to answer charges of high treason – potentially facing execution.

Sheffield Manor Lodge.

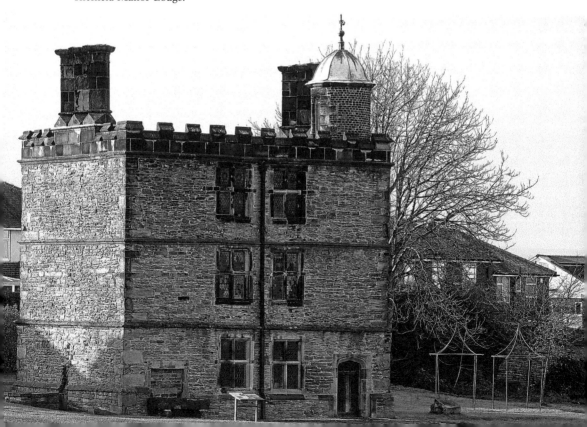

Sheffield Manor Lodge chimney.

The archbishop was not the most famous incumbent at Sheffield Manor Lodge. That claim lies with Mary Queen of Scots, who was held prisoner there by Elizabeth I and under the supervision of the Earl of Shrewsbury. The 6th Earl was married to Bess of Hardwick, one of Elizabeth's main ladies of court. She was the person behind Hardwick Hall and her dynastic legacies included Chatsworth and other great estates. In the late 1500s there was a complete rebuilding of much of the property including a grand entrance, brick-faced octagonal towers, a courtyard, and a new garden layout – a residence fit for a queen.

Today, however, the most interesting remains are those of the Turret House, the Elizabethan summerhouse or standing. Having fallen into total disrepair by the mid-1800s, the Duke of Norfolk in 1873 commissioned a survey and restoration of what remained. It is to this action that we owe the currently restored, three-storey building.

4. The Old Queens Head, or the Hall-in-the-Ponds

Formerly called 'The Hawle in the Poandes' this historic pub, one of Sheffield's few remaining timber-framed Tudor buildings, was the feasting lodge for Sheffield Manor Park, located close by the fish ponds and the River Sheaf. Believed to date back to 1475, after serving as the banqueting house it may have been a wash house for Sheffield Castle and Manor Lodge. An early account book of the Duke of Norfolk's estate notes states, 'the old house in the ponds, formerly wash-house to Sheffield Manor' (17 July 1770). The ponds were originally for breeding carp for the table by the monks of Beauchief Abbey –

The Old Queens Head.

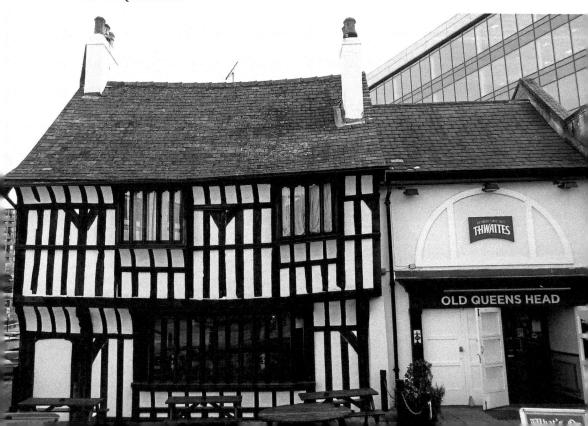

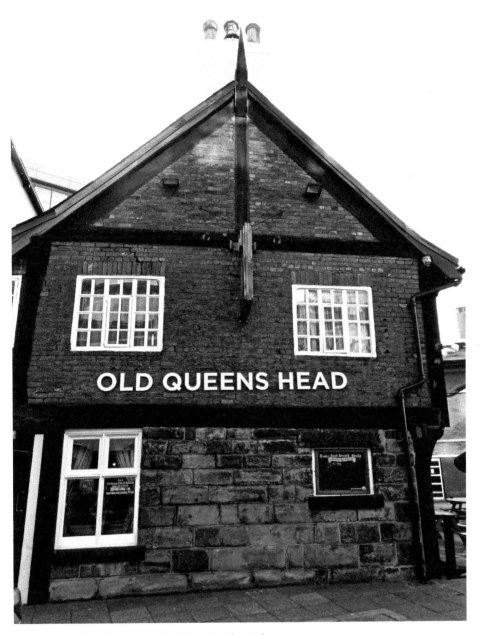

Side view of the Old Queens Head showing the timbers.

monasteries had a monopoly on fish-rearing. Before abolition, fish on a Friday or certain saints' days meant carp from the fishpond. Used as a residence, the dilapidated structure acquired in 1842 became a beerhouse for James Pilley, a rivet and nail-maker, with a cost of 2 guineas licence money. Originally in the building adjacent to the medieval structure, the pub later extended into the full premises. A butter dealer and mason named Joshua Ogden also used the premises. Much of the local land and the lease of the Old Queens Head was

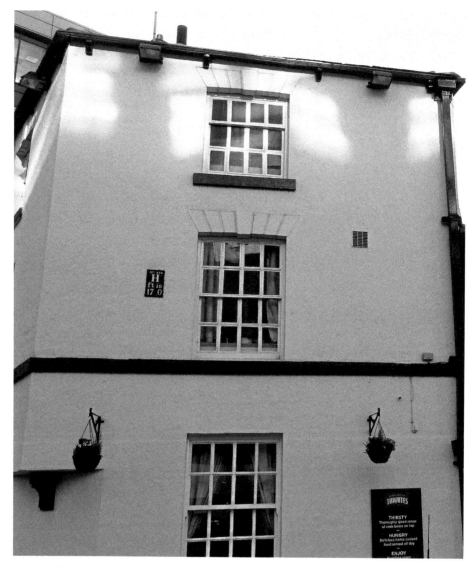

A later addition to the Old Queens Head Tudor building.

owned by local brewer Thomas Rawson, until passing to Truswell Brewery in 1892. The property then consisted of a bar, a bar parlour, a taproom, a kitchen and three bedrooms. By 1884, the ownership was acquired by Thomas Berry, then the Sheffield-based Tennant Brothers brewery, and hence to Whitbread. By 1935, the building was owned by Sheffield Corporation and leased to John Smith's Brewery of Tadcaster

Extensive refurbishment and renovation took place in 1949 that included removing decades of plaster, whitewash, and general grubbiness, which uncovered the original timbers. The old fireplace was revealed and stone-mullioned windows were discovered inside the building. Excavations for a new cellar exposed the site of the old well. The building was given Grade II-listed status in 1952 in order to provide some protection for the conservation of this historic site. The name may derive from Mary Queen of Scots, who was imprisoned in Sheffield from 1570 to 1584.

5. Bishops' House, Meersbrook Park, Norton Lees Lane

A photograph in the early twentieth century shows Bishop's House at Meersbrook and a row of old cottages to the side, though these have long since been demolished. William Blythe, the early owner, was buried at Norton Church; the following is inscribed on a gravestone in the porch: 'Here lieth the body of William Blythe of Norton Lees, who was buried here on 9th February, in the year 1665, being in the 57th year of his age.' A painting by Blore in 1823 shows the building as part of a working farm, with haystack and seated figures – a man and a woman – and a bent figure of a man busy working with a long-handled wooden tool. A wicker basket is on the ground nearby and another long wooden shaft is sticking through the basket handle.

The house today stands within Meersbrook Park, to the south of Sheffield city centre, and is the area's most outstanding timber-framed house. The naming of the house is a mystery since it never had any actual 'bishops' resident there. However, it was built around the end of the fifteenth century and owned by the Blythe family, two of whom went on to become bishops: John, Bishop of Salisbury, and Geoffrey, Bishop of Coventry and Lichfield. Nevertheless, their actual historical connection to the house is merely speculation. The building was subsequently owned by the Roebucks and the Shore families (bought by William Shore in 1753), and lived in by various generations of tenant farmers. The latter resided there and farmed the land when this was still in Derbyshire from the eighteenth through to the late nineteenth century. In 1886, and now in Sheffield, the ownership of Bishops' House passed to Sheffield City Council and the Meersbrook estate became a public

Bishop's House.

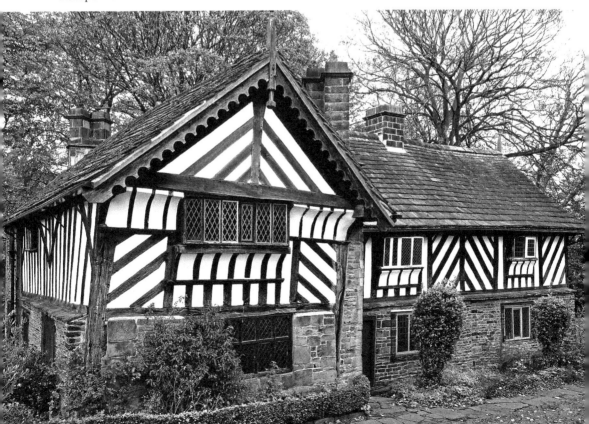

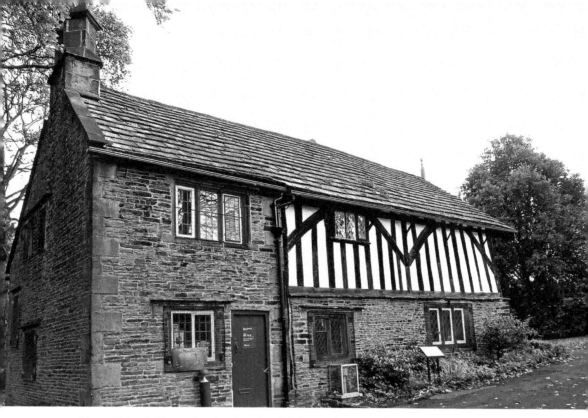

Above: Bishop's House showing the mix of timber and stonework.

Below: Detail of a window on Bishop's House.

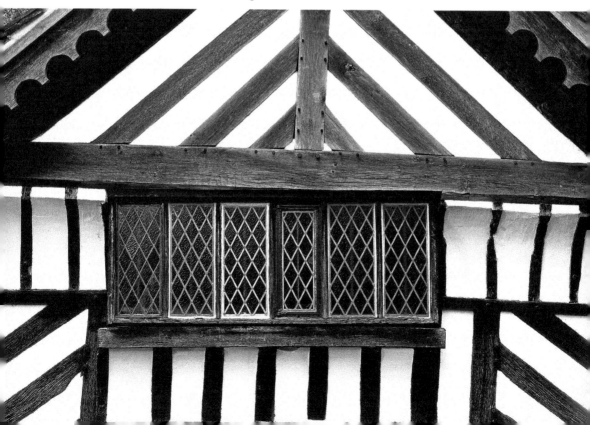

park. During this time various Parks and Recreation Department employees lived in the house until 1974, when, after refurbishment, the site opened as a museum in 1976. Today, Bishops' House is a Grade II* listed building and is cared for by a dedicated friends group.

6. Broom Hall, Broomhall Road

One of Sheffield's hidden treasures is the historic Broom Hall, which is situated to the immediate west of the old Victorian town in what is now the Broomhall district of the city. The earliest surviving parts of the hall are timber framed; dendrochronology (tree-ring analysis) dates the timbers to around 1498. The house was built by the de Wickersley family, whose ancestral home, as their name suggests, was at Wickersley near Rotherham. The de Wickersley family were wealthy and descended from Richard FitzTurgis, who co-founded Roche Abbey, also in South Yorkshire. It seems that the family jettisoned their Norman name (FitzTurgis) in favour of 'de Wickersley' after the name of the manor that they owned. The hall passed to the Swyft (or Swift) family when Robert Swift of Broomhall married Ellen, the daughter and heiress of Nicholas Wickersley. Nicholas was the son and principal heir of John Wickersley of Wickersley and now of Broomhall.

In the sixteenth century, after marriage to a Swyft heiress, Broom Hall became part of the estate of the Jessop family. In around 1614, the new owners built an extension to the hall and later rebuilt other parts of the house. The east wing was a 1784 feature added for the then owner, the Vicar of Sheffield, Revd James Wilkinson. However, in 1791, while the vicar was still the resident owner, protests took place against land enclosure acts, and a rioting mob attacked the house and set it on fire. The vicar, along with Duke of Norfolk, was one of

Broom Hall.

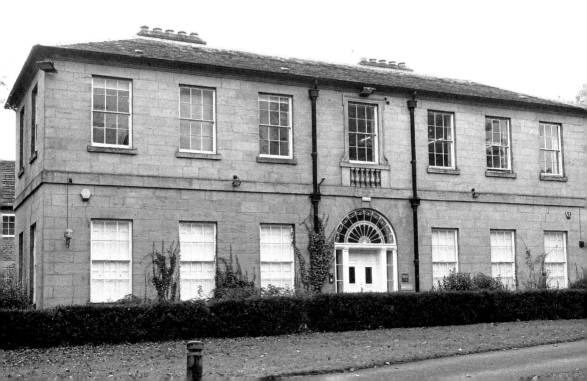

the main beneficiaries of the acts, which locally took many thousands of acres of common land from the poorer commoners for the gain of just a handful of the wealthier citizens.

After repairs and restoration during the nineteenth century, the hall was split into three separate accommodations. In the late twentieth century the premises were brought back together, as the home and workshop of eminent cutlery designer David Mellor from 1973 to 1990. The house was once again restored in 1988 and the Grade II*-listed building was then converted into accommodation for use as offices.

7. Abbeydale Industrial Hamlet or Tyzacks' Works, Abbeydale Road

Sheffield's reputation was built on metal production and metalworking, and the Abbeydale Industrial Hamlet is the most significant example of an early metalworking site still remaining. It was also one the first industrial museums in the world. The works exemplify the importance of water power and proximity to woodland for charcoal supply to the local metalworking industries, such as sickle and scythe manufacturing. Abbeydale may date back to before 1676, when a cutler's wheel was built in the area for Sir John Bright. The premises were certainly operative by 1714 and the works became especially significant as they undertook a range of processes from the working of raw materials to the production of finished products. Very often the works concentred on a particular stage of the process and not the whole thing, and in this sense Abbeydale was distinctive.

The main product was of agricultural sharp tools and the works were owned by a number of different operators as tenants until the Tyzack family in 1848. The latter remained there until 1933, and the works were sold to local philanthropist Alderman J. G. Graves in 1935. He presented the site to Sheffield City Council as an industrial heritage museum, which finally opened in 1970. The site has since undergone major restoration and refurbishment in the

Abbeydale Hamlet.

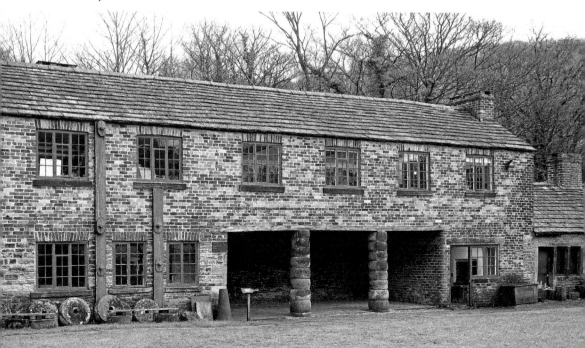

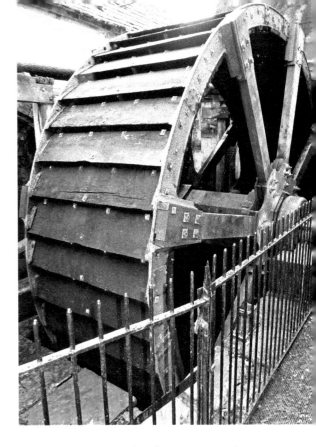

A waterwheel at Abbeydale Hamlet.

early 2000s and again more recently to provide full visitor, educational and interpretational facilities. Immediately west of the site is the 2-hectare Tyzack's Dam, a millpond to supply a head of water to turn the wheels and power the industrial plant. Steel was made in a crucible shop, built in 1829, with five melting holes. The two-storey tilt forge was constructed in 1785 and the grinding hull around 1817. There were four waterwheels, power tilt hammers, a two-cylinder blowing engine, grinding machines, and horizontal boring machinery. By 1855, the operators had added a single-cylinder steam engine as a secondary source of power – water-power was free but unreliable. Abbeydale Industrial Hamlet's claim to fame is that it demonstrates all these various processes in one location, and even today, with demonstrations by 'little mesters' such as Peter Gribbon, you can get a real feel of how these sites operated.

5. Shepherd Wheel, Bingham Park, Endcliffe

Shepherd Wheel is another (but smaller) working industrial museum in a former water-powered grinding workshop, located on the Porter Brook south-west of Sheffield city centre. This was one of the earliest wheels on the Porter, one of the few remaining today, and relatively complete. This is an example of the type of enterprise formerly commonplace around Sheffield. The site has an overshot waterwheel powered by a head of water from a large dam. The workshops, dam, goit, and weir are all Grade II listed, and the site is also a Scheduled Ancient Monument. The wheel was already operating in the late 1500s, as it was mentioned in the will of local cutler William Beighton in 1584. It seems that by 1794 the tenancy had passed to a Mr Shepherd (after whom the site is now named), and from the

The Shepherd Wheel workshop.

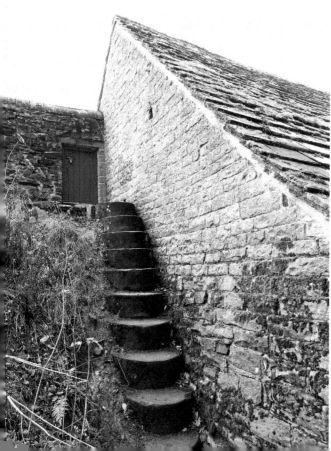

Shepherd Wheel with steps from old grindstones.

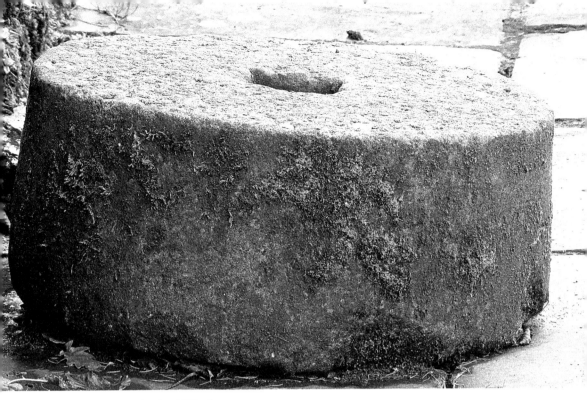

A grindstone at Shepherd Wheel.

1820s the site was operated by the Hinde family. The latter worked the mill for more than a century until the operations finally ended in around 1930.

The mill and its land were owned by the Duke of Norfolk's estate, until in 1900 Sheffield City Council purchased Whiteley Woods as a public park and the wheel and mill were included in the acquisition. Various local historical societies and conservation bodies campaigned for the restoration of the by then dilapidated premises, and as a result the site was opened as a museum in 1962. However, following serious financial problems for the city's Museums Department, the facilities closed in 1997. In 1998, the works were placed within the management of the newly formed Sheffield Industrial Museums Trust, and funds were raised for a significant restoration. Following a £500,000 Heritage Lottery Fund grant towards conservation and restoration, the Shepherd Wheel Museum was reopened on 31 March 2012. The museum, as it is today, has a waterwheel, two grinding hulls (rooms with multiple large grinding wheels operated by the waterwheel and built into the floor), and grinding wheels. There is also a collection of tools and equipment on show, which provide a remarkable insight into the lives and work of the former Sheffield craftsmen.

9. Paradise Square

More than a single building, Paradise Square is the city's best preserved and most elegant collection of Georgian houses. However, all is not as it seems: the distinctive red-brick buildings, which appear to have a unique coherence for Sheffield, were comprehensively restored between 1963 and 1966. Some of the houses – such as Nos 18 and 26 – were virtually rebuilt with materials salvaged from elsewhere. So, while the effect is charming

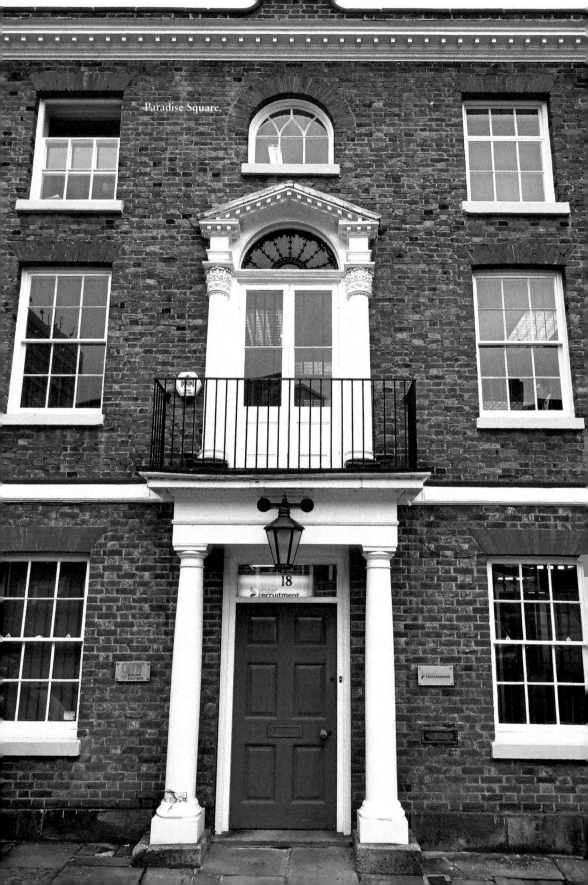

Paradise Square.

18

linear
recruitment

BUILDING
SOLUTIONS

linear
recruitment

and remarkable for Sheffield, it is not entirely authentic. The earliest houses here date from 1736, when Nicholas Broadbent built a terrace of three-storey three- and four-bay properties down the slope on the eastern side. These houses actually fronted onto the dismally named Workhouse Croft (renamed Paradise Street), which went down through fields and orchards to West Bar; Georgian Sheffield was still a very rural locale. Houses No. 4 and No. 6 still retain much of their original character and authenticity. Other properties in the terrace have been altered and modernised to varying degrees over the decades.

From around 1771–90, local banker Thomas Broadbent continued the development as he set out the other three sides of the square with a variety of tasteful properties. These varied from very modest two-bay houses such as No. 24, to quite imposing residences such as the five-bay No. 18. Some of the properties around the square have suffered varying degrees of unsympathetic, or at least uninformed, modifications and restorations over the years, but the overall impact is very pleasant. Paradise Square is in the heart of Sheffield's remaining Georgian quarter of the genuinely old town, and considering the fate of much else around it, it is remarkably intact. Campo Lane and St James's Row are close by.

1C. Victoria Quays, Furnival Road

Very much a hidden part of Sheffield's history and heritage today is the Tinsley Canal and the associated wharfs, quays and other buildings. To get a view of a very different city, take a barge trip down the canal from the city centre to Tinsley Locks, near Meadowhall.

Victoria Quays.

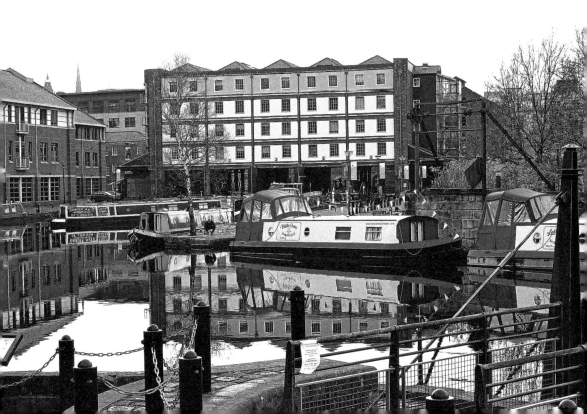

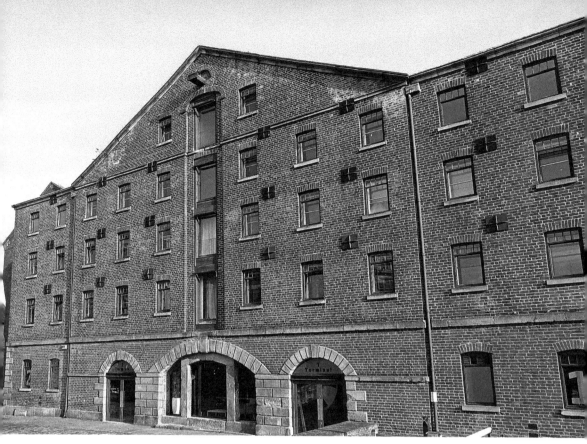

Victoria Quays.

This city centre site was developed as the Canal Basin between around 1816 and 1819 to serve the newly opened Sheffield and Tinsley Canal, as promoted by the Sheffield Canal Company. The objective of this important project was to link Sheffield centre to the River Don Navigation, which was completed in 1751, and thus to provide direct transportation routes to the coastal trading towns. Shortly after opening, the significance of the facility declined due to the advent of the railway transport network – the Victoria Station was located virtually next to the canal. By 1968, the Sheffield Basin had been replaced as the commercial base for the local canal network by a facility in Rotherham. The final commercial cargo arrived in Sheffield in 1970.

The Basin is comprised of a good range of interesting industrial and commercial premises including the former coal yard, Coal Merchant's Offices, and the Terminal Warehouse. Perhaps the most striking building is the Straddle Warehouse, which was built in 1895–98 with a steel frame and concrete infill supported by blue-brick arches. The building has red-brick end walls and five major docking bays. Since 1992 the whole area has been redeveloped and the Straddle Warehouse, for example, restored by Robin Hedger. The redevelopment was not without controversy since the new commercial and upmarket residential premises necessitated the removal of much of the existing boating community as part of the general 'tidying up' of the area. Many of the people involved felt alienated by the regeneration process and, to an extent, still do. Furthermore, separated by a fast dual carriageway from the main central parts of Sheffield, the Canal Basin (now Victoria Quays) remains hidden from most locals and from almost all visitors to the city.

11. The (Old) Old Town Hall

There have now been several generations of town halls in Sheffield – the first three incrementally more grandiose until the recent return to downsized public services. The seventeenth-century Town Hall built for the town trustees was a very modest building located at the corner of the then parish churchyard. Despite this, it was the first public building in Sheffield designed by a named architect, William Renny. He was paid £2 3s for his draft design in 1699, and a further £200 as the builder in 1700. This unpretentious building was replaced in 1807–08 by the Old Town Hall, which was situated on Waingate and designed by Charles Watson. The premises were extended by Flockton & Abbott in 1866, and then again by Flockton, Gibbs & Flockton in 1896–97. By the mid-1800s the building was next to the new police offices and in part served as the magistrates' court, the two being linked by underground passages. The town trustees required accommodation for themselves and their own duties and also provided for petty sessions and quarter sessions in the courts. The building is still there, but in very poor condition; it is regarded as one of the most 'at risk' heritage buildings in Britain. Steps are now being taken for its restoration and hopefully an appropriate future use.

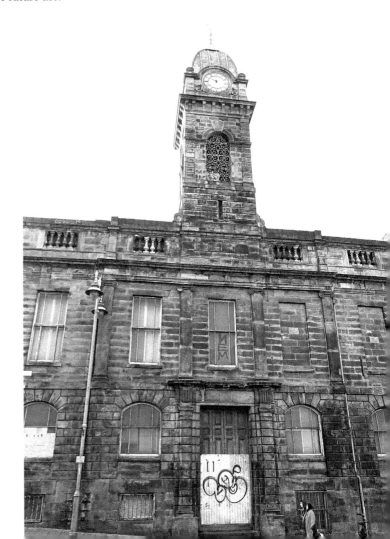

The old Town Hall.

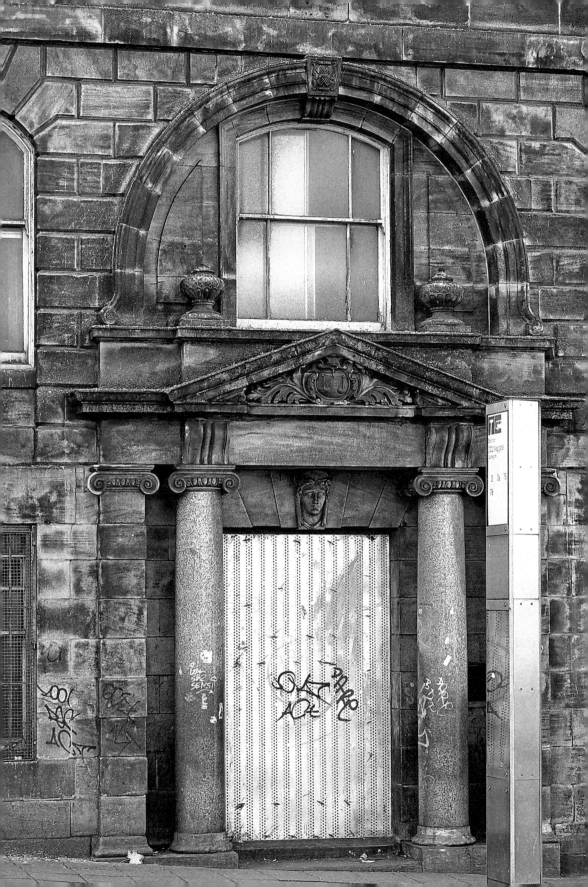

12. The Cutlers' Hall, Church Street

The present Cutlers' Hall was built in 1832 to a design by Samuel Worth and Benjamin Broomhead Taylor and extended in 1865–67 by J. B. Mitchell-Withers. The building occupies the same site as its predecessor, the second hall built in 1725, and probably of the first building of 1638. It remains as a statement of the wealth, significance and importance of Sheffield's major industries, particularly cutlery manufacture, and consequently its growing civic pride. This is undoubtedly one of the city's most splendid buildings, with its imposing Grecian exterior and sumptuous interior. The hall is a venue for entertainment, feasts, displays and assemblies, and the annual Cutlers' Feast provides local businesses with opportunities to meet, discuss and guide the affairs of the city and beyond.

Cutlery is synonymous with Sheffield, which has been noted for high-quality manufacture for nearly 800 years. The Company of Cutlers in Hallamshire was founded in 1624, and by the eighteenth century was the leading Company. As a craft guild, the Company was able to control and protect its trade, to administer apprenticeships, and oversaw the trademark 'Made in Sheffield'. In 1860, the Company extended its interests to incorporate the growing steel industry, and as such it grew in power and influence.

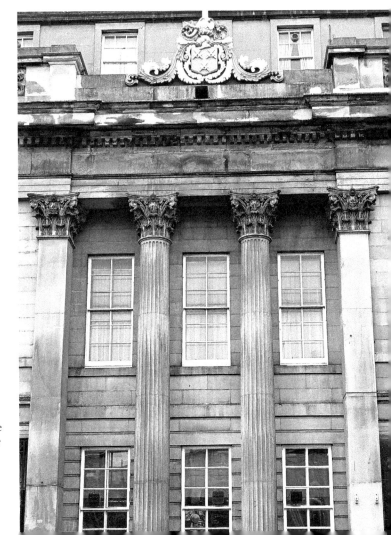

Right: The Cutlers' Hall.

Opposite: Imposing entrance to the Old Town Hall – now derelict.

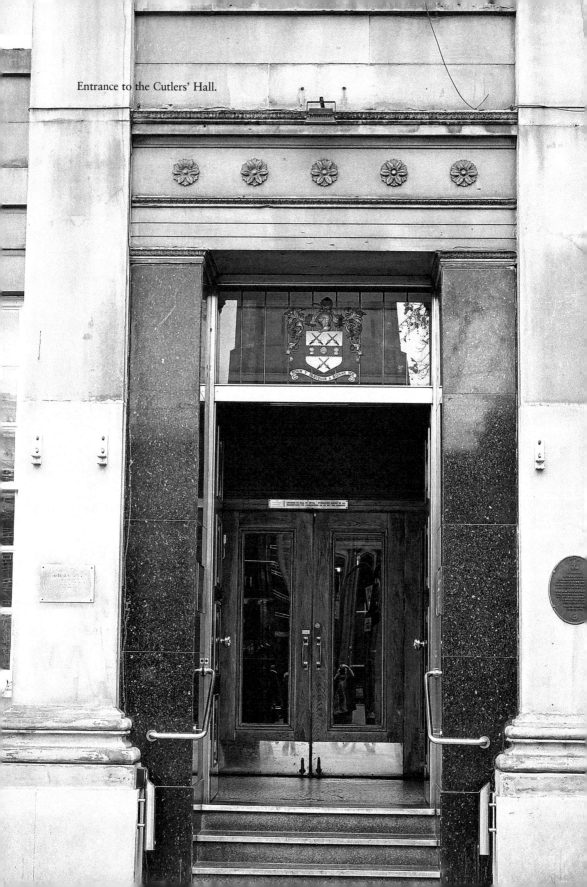

Entrance to the Cutlers' Hall.

Detail of stonework.

Squeezed in-between adjacent buildings, the hall exterior is only visible from the front on Church Street. The view is dominated by the central doorway, flanked by massive Corinthian columns with bays to either side, and fronted by more columns and an archway to one side. The exterior construction is in Derbyshire sandstone. To get a real idea of the hall means stepping inside to appreciate the three main halls or function rooms and the associated lavish ornamentation and decoration. The entrance lobby and hall lead to a main imperial staircase, which was doubled in size in the 1865 alterations. The reception rooms and Old Banqueting Hall are on the first floor and were joined in the 1865 works by the Large Banqueting Hall. The challenge with the Cutlers' Hall was to fit the aspirational settings into a rather confined and oddly shaped plot of land. Over the years, the incumbent Master Cutlers have added and donated various features and ornaments, and the buildings include the necessary offices and kitchens, etc. The ground floor includes the Master Cutler's Room.

13. Venture House, Arundel Street

Along what remains of Arundel Street, Howard Street and Charles Street are the buildings from a planned Georgian and Victorian expansion of Sheffield's urban centre. The whole area is laid out as a grid of straight streets set at right angles to the main thoroughfare. The buildings that remain give some idea of the type of scene to be experienced here in the late 1700s and early 1800s, as a busy collection of 'little mesters' and other more substantial works. The present streets, when not covered over with modern tarmac, reveal the granite cobbles and mastic of the original road surface. By the mid-1800s much of this area, with its live-in workshops, was in dire health due to air pollution – especially inhalation of silica from grindstones and also of metal from the metalworking trades – and awful insanitary conditions.

The properties are mostly late 1700s with Victorian additions, and among the best preserved is the complex at Nos 103 and 105 Arundel Street, the Venture Works or Venture

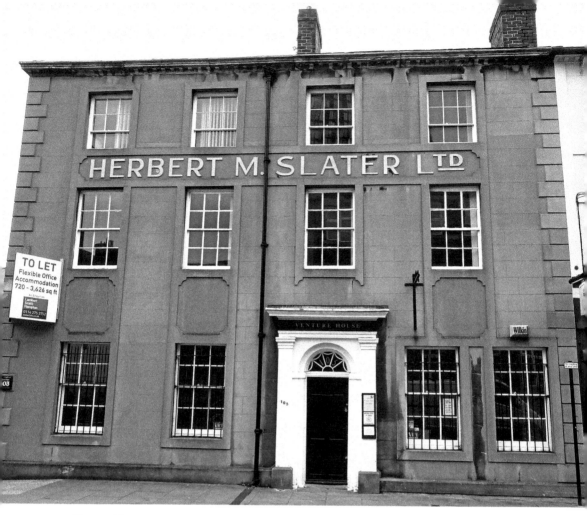

Venture House.

House of Herbert M. Slater Ltd. This building has a rear courtyard with a workshop added perhaps in the 1840s, and the interpretation is of domestic-scale premises adapted for industrial use. The interior of the buildings include the eighteenth-century timbers and the wooden rail hangars for part-finished knives or possibly files.

14. Butcher's Works, Arundel Street

Further down Arundel Street, but on the west side of the road, is the much more substantial Butcher's Wheel or Butcher's Works. This is a massive brick-built structure and though recently modernised, retains much of its exterior intact. The interior was still in part used for cutlery working until the late 1990s, and the premises were hired as a setting for television Victorian costume dramas. Certainly up to the time of the modernisation and refurbishment, this was Sheffield's best remaining integrated works for the manufacture of edge tools, cutlery and files. As a core part of the Georgian and Victorian extension of Sheffield centre with its grid of cobbled streets, the remaining buildings provide a feel for the expanding town of the day – minus the grime, dirt and pollution. Cleaned up and now with desirable urban

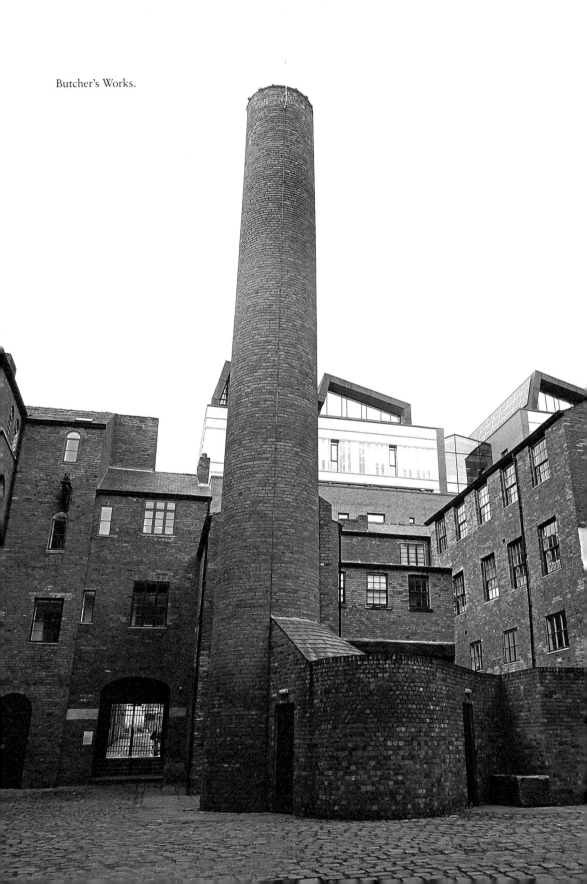

Butcher's Works.

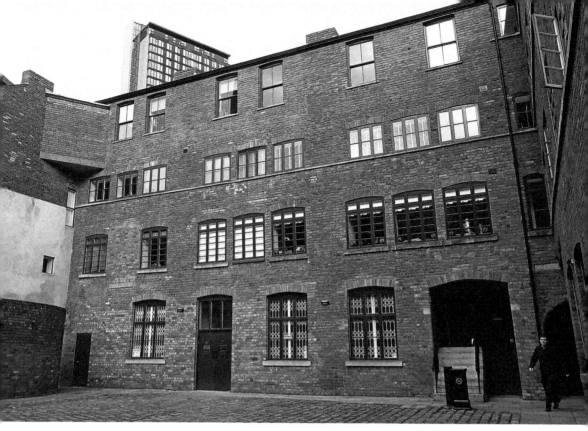

Butcher's Works.

residences, boutiques, cafés and educational facilities, the Butcher's Works site does provide a glimpse of the past in the present – albeit a gift-wrapped and sanitised version.

The premises as they are today were developed by William and Samuel Butcher and date mostly from around 1860, but they incorporated the earlier works (c. 1819) and face Eyre Street. There were two cart entrances, which are still visible, though closed off, and the older buildings are of three storeys. The later works had four storeys with a tall (130-foot) façade onto Arundel Street, presenting a very austere vision – a sharp contrast with some rather more grand works of the time. The centre of the yard is dominated by a huge chimney and at its base were privies concealed behind a curved wall to screen them. The stone-flagged yard was surrounded by workshops, a second-floor grinding hull, and fireproof brick vaults on the ground floor and first floor.

It is hard to appreciate the reality of the Butcher's Works in operation from the cleansed and scrubbed building of the twenty-first century; we see them without the noise, the smoke, the grime, and even the people. There were also the ubiquitous animals, which helped power and transport the products and raw materials of the Industrial Revolution. The premises and streets would have had horses, dogs, and of course, rats.

15. Collegiate Hall, Ecclesall Road

The twentieth-century teaching college at Collegiate began as Collegiate School, which was a boarding school for juniors and a university preparatory school for seniors. The site then became the Sheffield Royal Grammar School in the 1880s, and in 1906 was converted

Collegiate Hall.

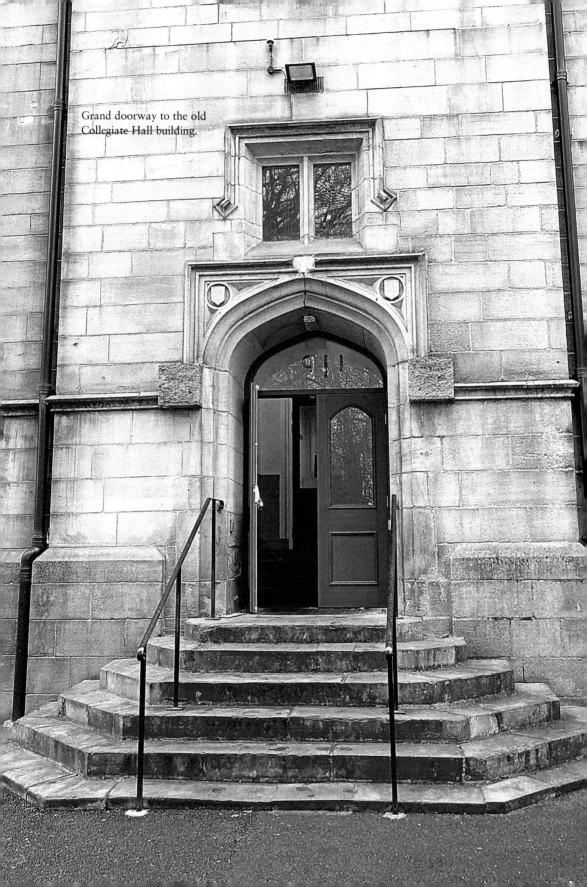

Grand doorway to the old
Collegiate Hall building.

into the University of Sheffield Teachers' College. However, in 1911, the college transferred from the university to the local authority and became the City of Sheffield Training College, but in the First World War was converted to use as the Third Northern General Hospital. It served as a base hospital for wounded soldiers.

Now at the core of the Sheffield Hallam University Collegiate Campus, the heart of this building is the former Anglican Collegiate School that was built in the perpendicular style to a design by J. G. Weightman in 1835 and 1836. The building had a central hall with two flanking wings each with two bays. Collegiate Hall was the headmaster's house, constructed in 1837 to a mock-Tudor design. Halls of residence designed by Gibbs and Flockton were added in 1906 when the school was converted to the teacher training college, and further additions were made by the city architect, F. E. P. Edwards, in 1911. The setting of these buildings was very different then from that of today. The school and later the college were originally constructed when the Broomhall area was a rural site on the edge of the town, but becoming a very affluent settlement of grand villas. Even today the area remains very leafy, but it has since become thoroughly urbanised and many properties have been subsumed into the former Polytechnic, (now Sheffield Hallam University), campus. There have been numerous additions and modification up to the present time, but the Collegiate building remains as the most striking feature when viewed from Ecclesall Road.

The Collegiate Campus is now one of Hallam University's main centres and remains at the heart of this very busy suburb. Along with the original Collegiate buildings, many of the former rather fine stone-built villas have also been acquired and turned to academic uses. These smaller units largely extend up the hill away from Ecclesall Road and the main building.

16. The Cathedral Church of St Marie (Roman Catholic), Norfolk Street

This Grade II-listed building is a particularly good example of an English Roman Catholic Cathedral and has some fine interior decoration and features borrowed from elsewhere and long predating the actual building. Of course, prior to the English Reformation under Henry XIII with the Church of England part of the Roman Catholic Church, Sheffield's medieval parish church of St Peter, (today's Cathedral Church of Saint Peter and Saint Paul), was the principal Catholic church in the area. However, this association ended with the split from Rome, though the main landowners in the region, the Dukes of Norfolk and their extended families were of Catholic leanings. As over time with growing tolerance extended to Catholic worship, up until 1933, the Shrewsbury Chapel of the Anglican parish church remained Catholic. During the re-ordering of St Marie's in 1970, at the invitation of the Anglican Cathedral, Mass was celebrated on the altar of the Shrewsbury Chapel once again. Work had begun on a formal base for Catholic workshop as Catholic emancipation grew during the late 1700s and into the 1800s, and by the mid-nineteenth century the site of St Marie's was chosen. Leading local architect Matthew Ellison Hadfield designed St Marie's after the fourteenth-century church of St Andrew's at Heckington in Lincolnshire. The church was completed in 1850 and opened on 11th September that same year to serve the whole of Sheffield as part of the Diocese of Beverley.

During the Second World War Sheffield Blitz, a bomb blew out the stained glass windows of the Blessed Sacrament chapel. Then, as a precaution, the remaining windows were removed and stored in a mineshaft at the nearby Nunnery Colliery. Unfortunately however,

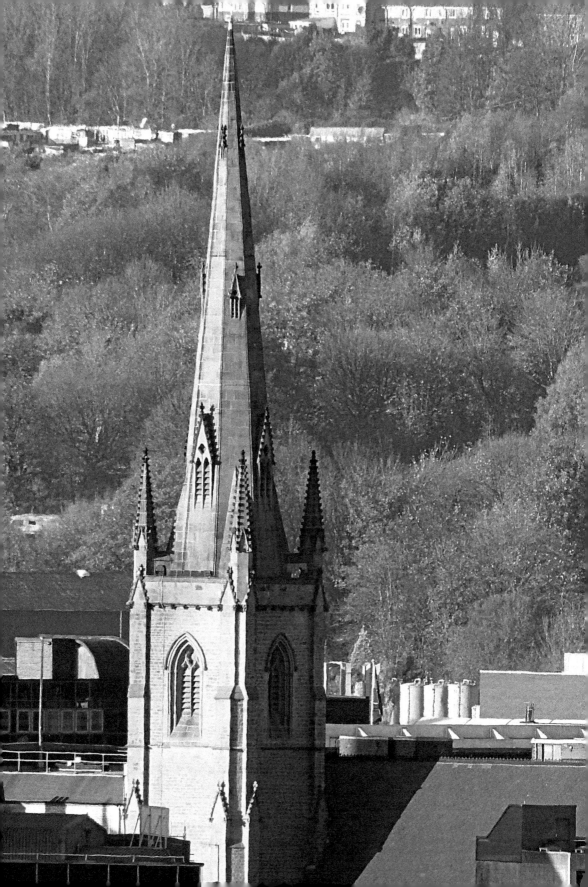

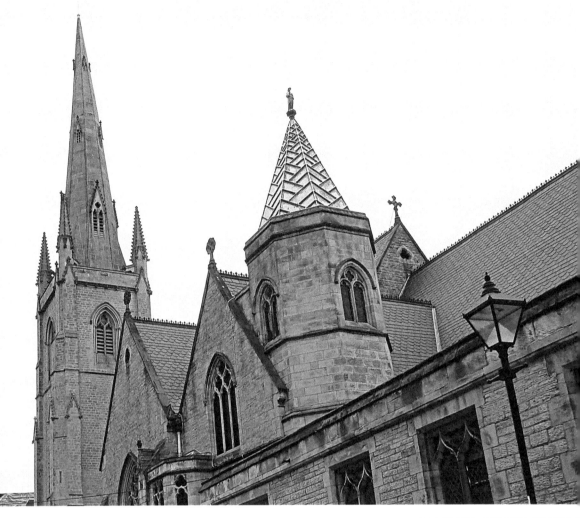

Above: The spire of St Marie's Cathedral.

Right: St Marie's Cathedral with stained glass and ornamental stone setting.

Opposite: St Marie's Cathedral spire.

the mines flooded and with the glass submerged beneath mud the drawings needed to recreate the windows were also lost. Nevertheless, the windows were re-instated in 1947.

On 30th May 1980, the new diocese of Hallam was created and St Marie's church became a Cathedral with an incumbent Bishop. To be fully appreciated St Marie's has to be viewed from the inside as well as from the outside; the latter best seen from Tudor Square.

17. Devonshire Green, Devonshire Street

In 2015, plans to demolish a unique group of independent shops on Devonshire Street including long-standing book and music store Rare and Racy were approved by Sheffield Council. This was despite massive objections and a petition with over 18,000 signatures against the proposals. Developers submitted an application to demolish numbers 162 to 170 Devonshire Street, home to long-standing businesses the Natural Bed Company and Rare and Racy, and also the Rag Parade vintage store and Syd and Mallory, for flats, restaurants and cafés. The result will be the replacement of independent traders on Devonshire Street by apartments, yet another restaurant, and a shop. The row of characterful properties that survived air raid bombings during World War Two will be displaced by another anonymous new development.

The buildings are a group of three-storey properties constructed about 1830. They have simple three-storey façades and typical Victorian brick-built rear off-shot rooms. The whole site had been in a single ownership for many decades but the elderly owner passed the

Devonshire Green.

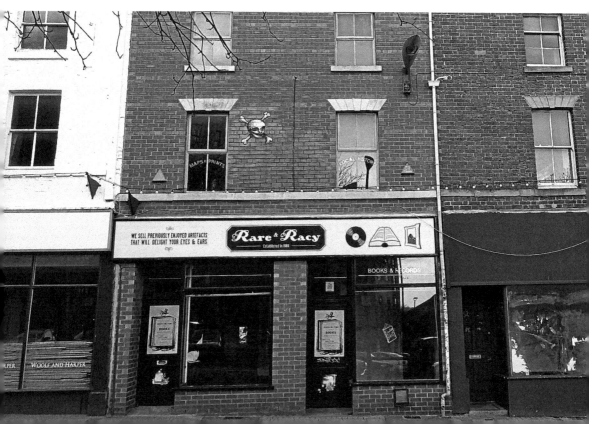

Devonshire Green.

premises to their descendants who wanted to capitalise on the newly acquired assets. The casualty was a mix both of local built heritage, and importantly for Sheffield, some long-standing independent and popular businesses. Indeed, this is an aspect of Sheffield where the city falls way short of the competition in cities like Nottingham and Leeds. This particular loss will dent that local provision even further.

The group of properties here is typical of those lost across the wider city, and which are 'nice' but not sufficiently 'special' to merit official protection. Just up the road from this casualty used to be the Raven pub, which became the Hornblower, and then was demolished for another bland modern scheme that could be anywhere. In part, this represents a limited coherence in the planning 'vision' for the city centre, and in part it shows the lack of effective protection and recognition of the ordinary more 'commonplace' architecture, which provides a 'sense of place'. The brave new world may include some decent designs and occasionally some stunning modern buildings. More often however, what we get is bland, bland, bland, rollout of whatever is in vogue at the time.

18. St Mary's Church, Bramall Lane

One of the city's most impressive churches is St Mary's, which is located where Bramall Lane intersects with the inner ring road. This was built to a design by Joseph and Robert Potter around 1826–30, and is in the perpendicular style with a tower of 140 feet

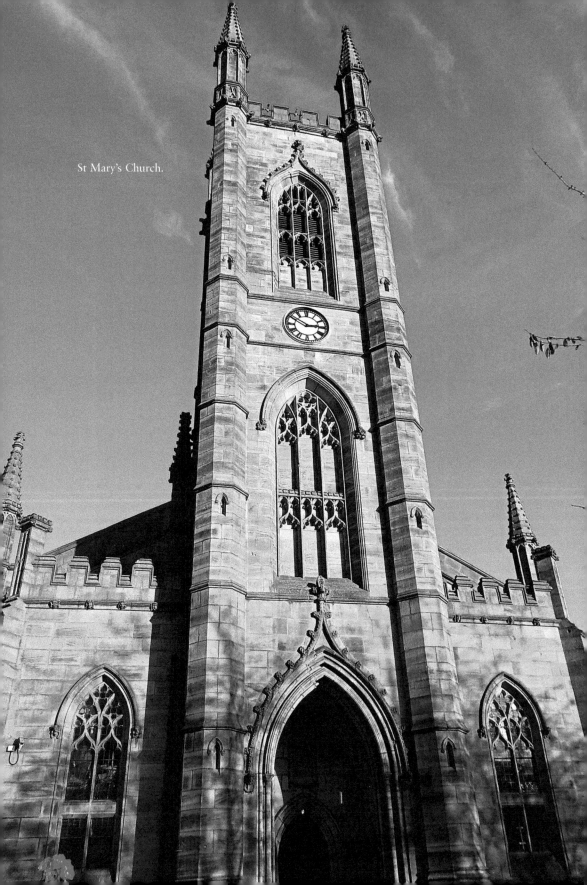

St Mary's Church.

Detail of stonework above doorway at St Mary's Church, Bramall Lane.

Detail of stonework around window at St Mary's Church, Bramall Lane.

(42.5 metres). The tower has tall pinnacles that are matched by the church buttresses, which have substantial crocketed pinnacles. The church has numerous other features of interest and significance, but was damaged by bombing during the Second World War. Following the end of the war, the repairs and restoration included the conversion of parts of this very large church into a community centre. Then, in the early 2000s, further work was undertaken to integrate the community centre functions more fully into a major resource for local people and community groups.

St Mary's was built as what was known as a commissioners' church, as part of a move to resolve deep-seated problems for the Church of England in the early 1800s. With population growth and the ever-increasing move of rural people to urban centres, the Anglican Church simply failed to keep up. On one hand it had to compete with Nonconformist chapels, which appealed strongly to the growing numbers of industrial workers, and on the other it needed to provide for increased footfall. Cities like Sheffield, for example, now had only 6,280 seats available for a potential congregation of 55,000. The response was money from Parliament to build new, urban churches – the Commissioners' churches. They were also known as Waterloo churches (because they were on the back of national pride in the victory), or Million Act churches (because the first act provided £1 million to begin the process). These Anglican churches were built with money voted by Parliament in the Church Building Acts of 1818 and 1824, which also established the Church Building Commission to oversee the work. The Commission was also empowered to divide and subdivide parishes, and establish endowments for the necessary clergy to bring the gospel to the working masses. Some money was also raised locally.

19. Hillsborough Barracks, Langsett Road

On a site begun in 1848, the massive Hillsborough military barracks were constructed by HM Office of Works from 1850–54. One of the biggest in Britain, the complex covered around 22 acres and was, in part, a clear statement (as in many industrial towns) of a strong military presence following Chartist unrest and demonstrations. Troops were recruited from beyond the immediate county, possibly to weaken local ties.

The design was based around a simple symmetrical Tudor style with crenulated towers, the officers' mess and accommodation fronted onto Langsett Road. The Langsett Road site was a replacement for the inadequate barracks at Hillfoot. Along with soldiers' accommodation and other functional areas like parade grounds (the infantry ground now a car park), there was a central Tudor-style gateway and a Gothic-style chapel (later converted to use as an on-site institute). To the east were cavalry quarters, stabling and a second parade ground. Munitions were in the magazine store and there were also mobilisation stores, squash courts, and a riding school.

Today a modern shopping facility, it is hard to image the barracks as that functioned through the mid-nineteenth century and during the First World War until their final closure around 1930. Even more difficult is perhaps imagining the night of Friday 11 March 1864, when the ill-fated Dale Dyke Dam, higher up the nearby Loxley Valley at Bradfield, burst its dam wall. This caused the 'Great Sheffield Flood' and, with the River Loxley on the northern side of the barracks, the waters burst through a 3-foot-thick stone wall and rose to a height of around 12 feet outside the window of the quarters of Sergeant Foulds. The

Above: Hillsborough Barracks.

Right: Clock Tower at Hillsborough Barracks.

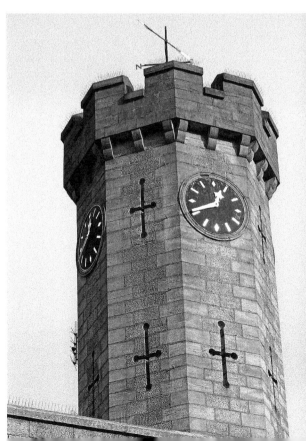

disaster was especially tragic in terms of lives lost because it occurred at night while many were sound asleep in bed; two of the sergeant's children drowned.

In 1990, with a design by the John Brunton Partnership, the Hillsborough Barracks complex was mostly converted into a modern facility mixing office and retail use. Most of the enclosing perimeter wall, with its crenulated towers, has been retained as a reminder of Sheffield's distant military past.

20. Upper Chapel, Norfolk Street

A member of the General Assembly of Unitarian and Free Christian Churches (the umbrella organisation for British Unitarians), Upper Chapel is a place of worship for Unitarians. The building is Grade II listed.

The history is that James Fisher, vicar of Sheffield Parish Church during the Commonwealth of England, was expelled during the Great Ejection for refusing to sign the Act of Uniformity 1662. However, around 10 per cent of his parishioners followed him as dissenters. In the 1690s, after subsequent divisions, the main Nonconformists group led by Timothy Jollie built Upper Chapel – Sheffield's first Nonconformist chapel. Constructed of brick, it fronted onto Fargate. Early congregations numbered around 1,000 people, nearly 17 per cent of the town's population.

In the 1840s the chapel was turned round to face across fields with the roof raised and the interior reconstructed, but leaving the two side walls intact. With alterations by John Frith completed in 1848, there followed various later changes to the interior such as

Upper Chapel.

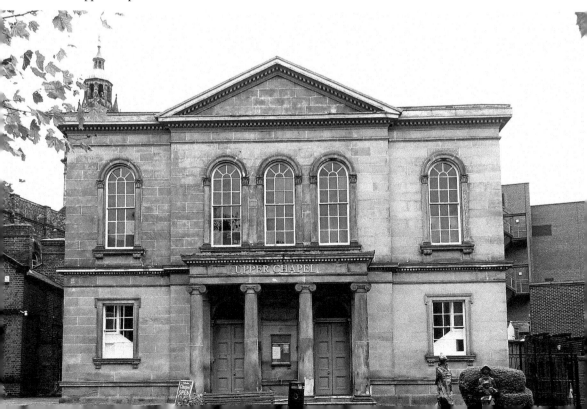

new stained glass windows by Henry Holiday. The building, completed in 1882 to a design by Flockton and Gibbs, links to Channing Hall facing Surrey Street. The hall is named after William Henry Channing, who served the chapel in 1875, and is of Italianate design.

21. King Edward VII School or Wesley College, Glossop Road

This impressive building was the site of the Wesleyan College, which became King Edward VII Grammar School and is now the upper school campus for King Edward VII Comprehensive School. The location remains impressive and must have been even more so in the semi-rural surroundings of its original establishment. Along with 'The Mount' further up the hill towards Broomhill (another Grade II*-listed site), this building was a major statement of wealth and aspirations of the soon-to-be city.

The original building was designed and built 1837–40 by William Flockton. This imposing building was exceptional for a school project of the time. It sits just below a similar looking private residence in classical Italianate style called 'The Mount' or 'Mount View'. Also built by Flockton, though slightly earlier in 1830–32, this was pioneering at the time of building and was exposed in a high, rural situation. It was soon nicknamed

The high tower, domed lead roof, and clock faces.

King Edward's School.

'Flockton's Folly' since it was too far out of town to attract buyers. Yet, emulating a trend begun in the Regency, the building appeared to be a country mansion that accommodated several separate homes, described as 'genteel dwellings'.

King Edwards followed with a colossal twenty-five bays, including a central entrance of seven bays with eight huge Corinthian columns, plus grand outer staircase. Alterations in 1905–06 removed dormitories and modified classrooms as Wesley College merged with Sheffield Royal Grammar School to form King Edward VII Grammar School for boys. The final eleven-plus entrance was in 1968, when the school converted to a comprehensive intake.

This significant, imposing historic building has an even longer heritage. The school can be traced directly back to a 1604 royal charter, establishing the 'Free School of King James' with a legacy from Thomas Smith, who died 1603. The lineage can be further tracked to the thirteenth century. The modern campus was altered and added to with more modern teaching facilities. The older building was listed as Grade II* in 1973.

22. Sheffield Botanical Gardens

Sheffield Botanical Gardens suffered decades of neglect and decline in the late twentieth century, but has more recently enjoyed resurgence in interest and gained investment from bodies such as the Heritage Lottery Fund. The original site was 18 acres and purchased

by the Sheffield Botanical and Horticultural Society in 1833 for the sum of £18,000 from Sheffield industrialists the Wilson family, the owners of the nearby snuff mill at Sharrow. Garden designer Robert Marnock won the competition to set out the new landscape, which he did in the gardenesque style consisting of a relatively informal layout with smaller-scale features such as rock gardens, ponds and trees planted onto roundels and mounds.

The gardens were opened to subscribers in 1836. Visitors were able to enjoy the garden rising up a gentle slope from Ecclesall Road to Clarkehouse Road with sinuous paths and wooded dells, interspersed with lawns and hidden features of interest. The top of the gardens open up to a series of splendid glasshouses with linking colonnades, and an impressive main gateway and entrance. The latter has a portico supported by paired Ionic columns, with a round arch and large central keystone and a long, curved wall fronts the garden offices and caretaker's house. There is now a café and shop. Entered from the Clarkehouse Road end, the glasshouses are on the right-hand side and overlook the sweep of the main gardens on the slope below. They are often called the 'Paxton glasshouses'; while perhaps inspired by the great man's work at nearby Chatsworth House, they were designed by Benjamin Broomhead Taylor, the man who came second to Marnock in the original competition. These structures have quadrangular domed roofs of iron ribs and windows with walls of locally quarried Hathersage sandstone with glazed panels and

Sheffield Botanical Gardens.

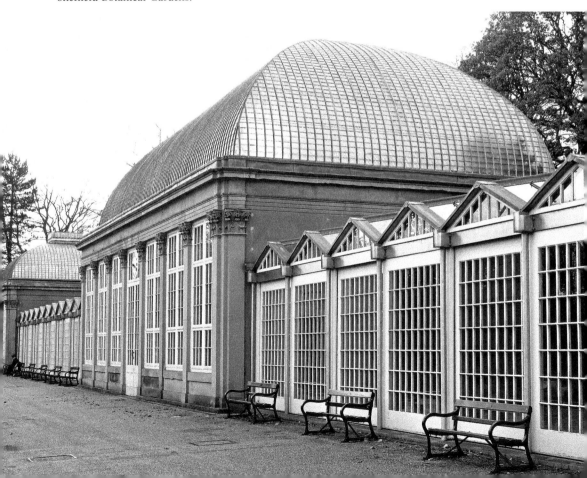

Corinthian pilasters. The three glasshouses (the central one is the largest and the two flanking ones are smaller) are connected by glazed lower-gabled colonnades. Some early images suggest that the colonnades are a later addition; they deteriorated later and the glass was removed before 1939. Local myth has it that the glass was blown out during the Blitz in 1940. All the buildings have recently been fully restored.

23. The Water Works Company Building, Division Street

This historic Grade II-listed building is managed as a Wetherspoon public house and was, for a time, the Lloyds No. 1 Café Bar. The pub is the remarkable building of the former Sheffield Water Works Co., and the result is one of the city's most striking venues. The company was formed in 1830 and the Division Street building, which opened in 1867, was designed for them by architects Flockton & Abbott. The ground floor has spectacular arched stone windows, each topped with a carved image of a water god. The striking cornice with its balustrade parapet has large stone urns and a date stone with '1867' engraved.

The premises were taken over by Sheffield Corporation's Transport Department and later became a part of the one-time NUM headquarters. For a few years this was Arthur Scargill's base when he led the National Union of Mineworkers. The Sheffield Water Works, part of the City of Sheffield Corporation (i.e. the local authority of the time),

The Water Works Company Building.

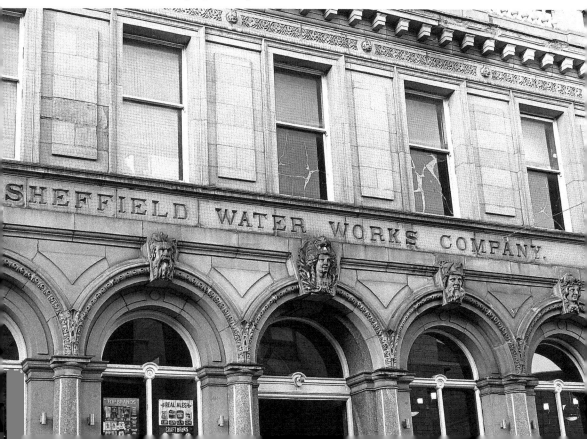

Date stone on the Water Works Company Building.

offices moved into the Castle Market building when that opened. Sheffield Water Works, taken over in the 1880s, disappeared in the 1970s with local government reorganisation and the creation of Yorkshire Water, who remained at the Castle Market building for many years after.

24. River Don Works, Brightside Lane

The last remaining stretch of what I describe as the 'Steel City Canyons' runs along the lower end of Brightside Lane with what remains of the frontage of the River Don Works. The works was built around 1863 for Naylor Vickers, which became Vickers Sons & Maxim in 1911. Close by was one of the earliest works here, with the Brightside Weir taking water from the Don to power the Attercliffe Forge from around the 1500s. A rural farming landscape was undergoing a major transformation, and by the 1900s the works eventually spread to cover around 100 acres of land on both sides of the road. A key driver for the Sheffield steel industry at this time was warfare, with the manufacture of armaments and armour plate, motor cars, shipbuilding and aircraft. As one of the top six industrial businesses in Britain in 1906, the offices to the north-west of the lane are fittingly impressive with a façade of twenty-eight bays in a symmetrical arrangement of pollution-resistant red bricks. Among the interior fittings is a sumptuously decorated boardroom, reached by a marble-lined staircase. It is suggested that these were – in part, at least – payment in kind for the supply of guns to Italy, but presumably this was when the Italians were sided with the Allies.

The factory here included many world-leading innovations including the tall, four-gabled gun heat-treatment tower in the southern area, which was designed by Sir William Arrol

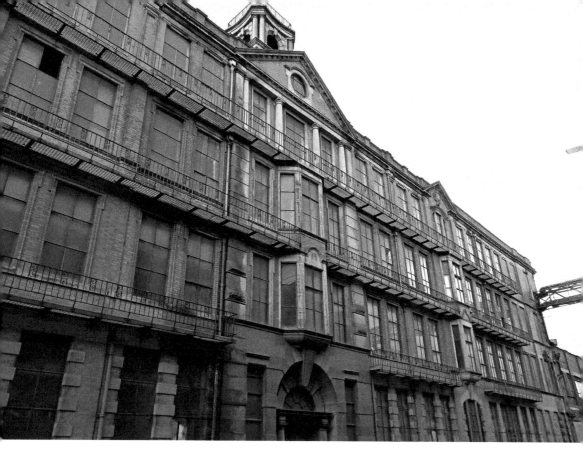

River Don Works.

in 1913. For many decades these premises were part of the Don Valley industry, which was at the forefront of production in special steels, weaponry, and naval and military armour. Even today parts of the site are still used by CORUS for heavy forgings, special steels and castings. The façade of the old works still gives a feel of the Lower Don Valley as it used to be, but you need to add the dirt, dust, grime, heat, noise and – above all – the men for full authenticity. This was hot, thirsty work and absolutely every street corner had a pub for the men to slake their thirst after each ten-hour shift.

25. The (New) Old Town Hall

Sheffield Corporation and then City Council has been through various phases of accommodation before the present-day cut-down base at Howden House. There was the early nineteenth-century Old Town Hall, the main (Victorian) Old Town Hall and a 1970s monstrosity simply known as the 'Egg-Box'. For many Sheffielders, though, their Town Hall will always be the one designed and built between 1890 and 1897 by E. W. Mountford and extended between 1914 and 1923 by F. E. P. Edwards, the city architect at the time. The result of these developments is a building that dominates a significant part of the city centre and the future uses of which are still being debated.

The search for a solution to the administrative demands of the growing town and emergent city had exercised councillors' minds for decades, but the costs of such provision

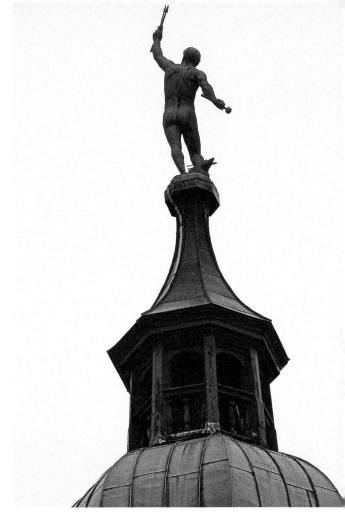

Vulcan standing proud over Sheffield's
'new' old Town Hall.

were always considered to be prohibitive; hence it was well into the late 1800s before
a solution was agreed upon. In the meantime, the councillors and paid officers operated
from a disparate medley of buildings scattered across the town centre. Eventually the site
was chosen and purchased as part of a general improvement scheme around New Church
Street and Pinstone Street and a competition was held, attracting designs from over 170
architects. The scheme settled on was that of Mountford, though there were complaints
made about other practice's ideas being 'leaked' to the competitors. The building work
undertaken by Edmund Gabbutt of Liverpool cost £83,945, and the overall bill, including
the latest in electric lighting, was over £134,000.

The overall style of the building is similar to great civic halls in other major industrial
cities and towns in northern England, with what is known as Northern Renaissance
architecture. The style features mullioned and transomed windows, small-paned
casements, and abundant chimneys, pinnacles, turrets, dormers, gables, all topped by the
asymmetrically placed angle-tower overlooking Surrey Street and Pinstone Street. The
clock tower is the seat of Vulcan, as a reflection of Sheffield's metalworking industries. The
building combined dignity and gravitas with utilitarian functionality: grand, ornamented,
meeting rooms and chambers jostling for position with working offices and a warren of
garrets, staircases and underground chambers.

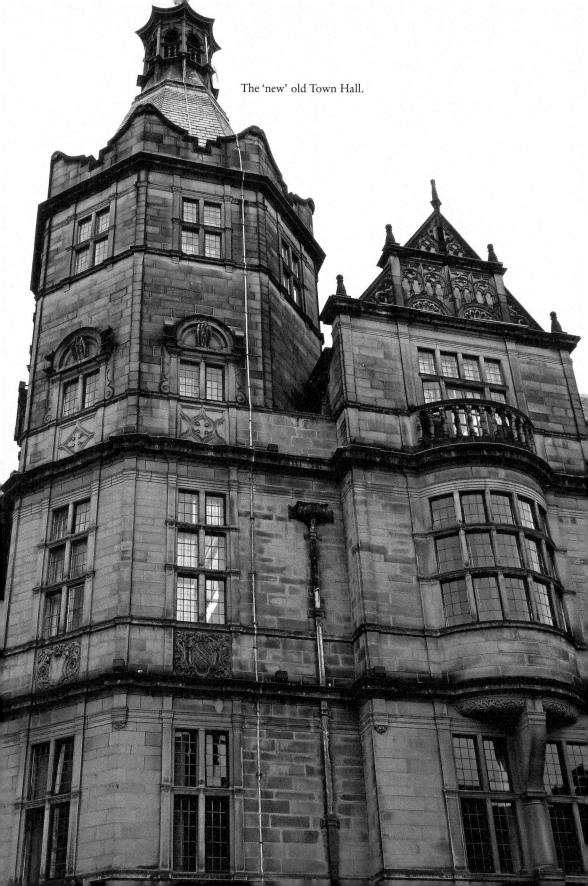

The 'new' old Town Hall.

26. Former Central School and Firth College (Now Leopold Square), Leopold Street

Leopold Street connects Church Street, West Street and Barker's Pool, and was built in 1870 to ease pressure on the rather narrow Orchard Street. On the right-hand side, entering from Church Street, the new premises for Sheffield Medical Institution were built in 1888 – originally founded on Surrey Street in 1828. The new school could accommodate 100 students and had a dissecting room, pathological museum, physiological laboratory, and teaching rooms. It remained here until moving to the new University of Sheffield site on Western Bank in 1905. Between 1876 and 1899, on the site bounded by the new Leopold Street, West Street, Orchard Lane and Holly Street, the Corporation built the Central School and offices for the School Board. However, in 1877 wealthy steel manufacturer Mark Firth acquired the adjacent site on West Street to build a venue to host the Cambridge University extension lectures – Firth College. This led to the brief for the original site, undertaken by Flockton & Abbott and E. R. Robinson, being extended to include Mark Firth's building. Completed in 1879, Firth College was subsumed into the new Sheffield University in 1905. This building was inspired by Clare College, Cambridge, with the entrance from West

Former Central School and Firth College.

Street resembling the college's gateway. The original building was of two storeys, but a third was added by Flockton & Gibbs in 1891–92. The buildings have robust stone façades topped by stone balustrades with ornamental carved features such as lilies and oak leaves.

The School Board offices became the Education Authority premises for many decades, and the Central School site was part of a scattered group of buildings still in use as the school until the late 1960s.

Conversion and refurbishment in the 2000s was successful in producing a good modern facility to enhance the café culture of the city centre, while at the same time maintaining the best of the heritage features. For example, inside the modern conversion of the complex to Leopold Square with a mix of food and office premises, the splendid oak-panelled boardroom is still present as a dining area in the Leopold Hotel.

27. The Mappin Art Gallery and Weston Park Museum, Western Bank

One of the culturally significant buildings for Sheffielders must be the Mappin Art Gallery with its 'annexe' of the Weston Park Museum, or City Museum, Weston Park. It was established with funding from the will of John Newton Mappin from his fortune made as owner of the Masboro' Old Brewery in Rotherham. He left a collection of 153 paintings to the city on the condition that there was an art gallery established to house them. His art

The Mappin Art Gallery.

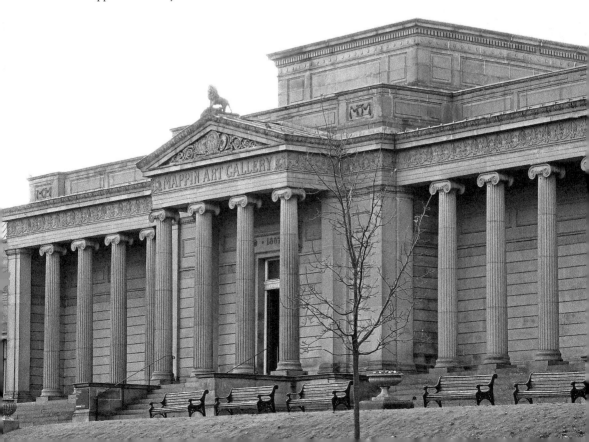

collection was further expanded by his nephew Sir Frederick Thorpe Mappin, and in 1885 the commission to build the requisite gallery was won by architects Flockton & Gibbs. Completion followed – at a cost of £15,000 – for a building that in 1959 Pevsner thought was pure Ionic and 'amazing if one considers its date'. The gallery has an Ionic giant portico with pediment and giant Ionic colonnades in the flanking recessed areas to either side of the front entrance. The cruciform central gallery by Gibbs (and where the Mappin paintings were displayed), with recesses and bays having independent ceiling lighting, was also innovative for the time. Almost all the building – save for the façade and two front galleries – was destroyed by bombing in 1940.

The annexe at the southern end of the building was added in 1937 by city architect W. G. Davies in order to extend the galley and house the Weston Park Museum. This did survive the Blitz. The sculptures, as a frieze above the entrance, show birds, fishes, reptiles, mammals and crustaceans to reflect the strong natural history focus of much of the museum along with its local history and geology.

The special gallery was rebuilt in the period 1961–65 and the museum had a major refit in the 1980s. In the last twenty years, the gallery space has been modified and subsumed into the extended but radically altered Weston Park Museum. Much of the curatorial excellence has sadly been watered down, but the displays provide a good experience for visitors and children.

The adjacent Weston Park was an important Robert Marnock design, but has suffered badly over the years. That is a story for another time!

28. The Lyceum Theatre, Arundel Gate

In 1893, the Lyceum was opened as the City Theatre, which was designed by Walter Emden with Holmes & Watson but considerably altered only four years later to a design by W. G. R. Sprague. It was the latter who created the splendid interiors of the theatre to

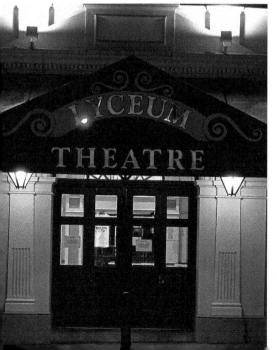

Left and opposite: The Lyceum.

rival any in the country. By the 1980s the Lyceum was the only surviving theatre of the one-time four that were in the city centre. By this time its repertoire had changed from theatre to being a lesser concert hall for pop and rock bands. Old established groups such as the Kinks performed there, as did up and coming ones like U2 before it finally closed.

However, following huge public effort and a demand for an effective but traditional theatre in Sheffield to complement rather than replace the Crucible, the Lyceum was renovated between 1989 and 1990 with a scheme overseen by Renton Howard Wood Levin Partnership. The exterior stucco decorations were reinstated and the statue of Mercury returned to the dome. New staircases and access were tastefully incorporated into the modern extension onto Tudor Square. The old building had included a complex arrangement of entrances and stairs to effectively separate the patrons by social status. Needless to say, this system was done away with.

The rear of the building was enlarged and a new larger stage created, along with dressing rooms and rehearsal space. However, the absolute gem of the new Lyceum is the interior of the auditorium with stalls, cantilevered balcony and circle, and boxes to either side. For those who suffer stiff knees, the space is challenging, but the Rococo plasterwork is more than adequate compensation. The auditorium is full of drapery, scrolls, shells, and garlands that join the coved and panelled ceiling with its delicately painted musical instruments and botanical foliage. The Lyceum is a thoroughly modern theatre but one that retains its heritage and its authenticity.

29. Victoria Hall, Norfolk Street

Victoria Hall, a Grade II-listed building on Norfolk Street, is a Methodist place of worship and important for social functions and care. A mix of Gothic and Arts and Crafts styles, it is the work of Waddington Son & Dunkerley in 1906 and especially a

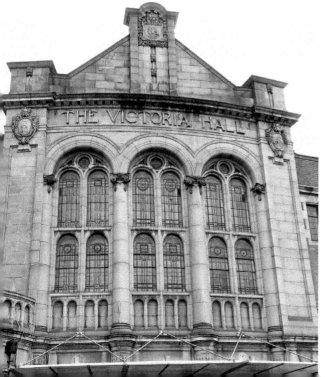

Left and opposite: Victoria Hall.

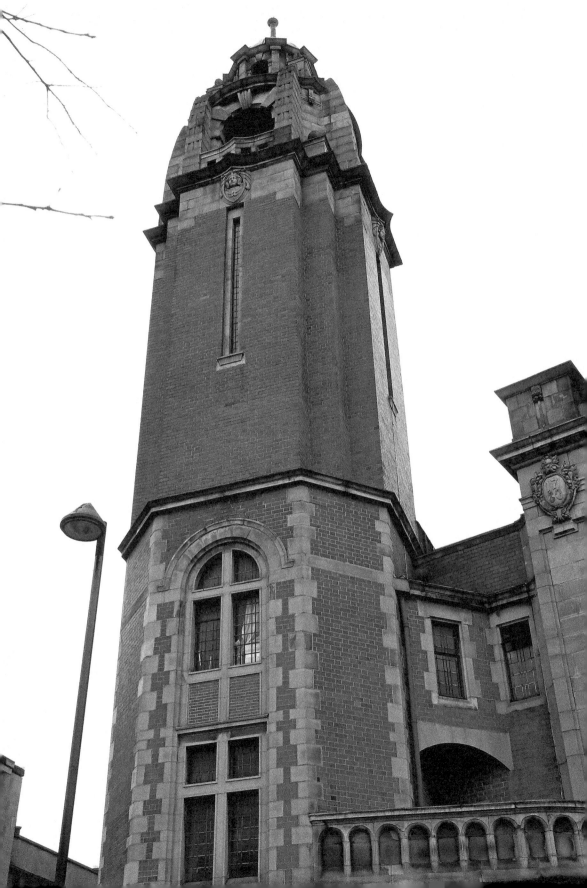

1908 reworking by Alfred & William Tory. In particular, the latter created the massive baroque top to the main tower, a significant feature for this city centre site. A large many-roomed building between Chapel Walk and George Street, this is the most important Methodist building in Sheffield. Today's Victoria Hall is on the site of the earlier Norfolk Street Wesleyan Chapel, which was opened and consecrated in 1780 by John Wesley. At the time it was said to be 'one of the largest in the Kingdom'. The building needed major renovation with new vestries in 1875, costing £6,000. However, in 1906 that chapel was demolished and the modern structure erected in its place, and on 26 September that year the foundation stone of the new Victoria Hall was laid. The Hall opened on Thursday 24 September 1908, having cost over £40,000. The carved decorations on it were by Alfred & William Tory, and images of the Wesley brothers were integrated into the design.

30. The Midland Station, Sheaf Square

From the 1800s to the 1960s the railways became hugely significant transport arteries for both Sheffield's people and industrial produce; the city had two major stations and many smaller local ones. Today, the Midland railway station is the city's only main station and is at the heart of the Transport Interchange in the city centre. Numerous smaller stations and lines have closed over the years, though today new ones are opening.

The station was opened in 1870 for the Midland Railway to the designs of their company architect, John Holloway Sanders. It was the fifth and last station to be built in Sheffield city centre. The line replaced the Midland Railway's earlier route to London, known as the 'old road', which went via Sheffield Wicker and Rotherham. The biggest city centre station was the Victoria station, which was situated around half a mile away and ultimately a casualty of the 1960s Beeching cuts. In 1905, the Midland station was significantly remodelled by Charles Trubshaw, the company's architect of the time. Interestingly, however, the Sheffield Midland station appears to have been something of a one-off design and unlike most of his other work. The main building is mostly classical in form and faced with fine ashlar (fine-cut masonry stone) from Peasenhurst quarry in Derbyshire. It features a cast-iron porte cochère or entrance behind a gabled, arcaded stone screen. The decoration of the original refreshment rooms is generally preserved, though the glass roof that spanned the tracks has long since gone and been replaced by individual canopies with steel frames.

In recent years the station has undergone considerable, and indeed the much-needed, refurbishment and upgrading, which inevitably means the loss of some original features. There are some parts of the 1870 construction still present, such as the offices on Platform 2. The modernised station includes improved entrance and information areas and leads to the award-winning 'Heart of the City' landscape, running from here to the city centre.

The station also boasts its own pub, The Sheffield Tap, run by Thornbridge Brewery and claiming the largest selection of draught beers in the city centre.

Above and Below: Midland station.

31. Carterknowle Junior School

This is just one example of a rich, yet often under-appreciated, resource of architectural heritage in Sheffield. The reason for this significance is that Sheffield has one of the best surviving collections of early board schools in England. Indeed, the schools form an example of such provision that is unmatched anywhere except in London itself. After the 1870 Education Act, Sheffield's newly elected School Board was stimulated into energetic action to build new schools across the city. Before the board was reorganised in 1903 as the Sheffield Education Committee, they finished thirty-nine schools, with Charles J. Innocent appointed as their architect. Along with his partner, Thomas Brown, he was responsible for nineteen out of twenty-two schools constructed from 1873 to 1881. The first built under the act was Newhall School on Sanderson Street, and by 1877 the number of pupils attending had swelled to around 31,000.

Carterknowle Juniors was one such board school built in 1906, in this case by Holmes & Watson for the Sheffield Education Committee. The building is Arts and Crafts in style with coursed squared stone, ashlar dressings, and gabled, hipped slate roofs with a variety of stacks. Typical of these buildings, the monument record notes that the windows are mainly transomed glazing with bar casements, and the central hall is surrounded by single-storey ranges with a central, octagonal, wooden, bell turret, a shallow lead dome and finial. The

Carterknowle Junior School.

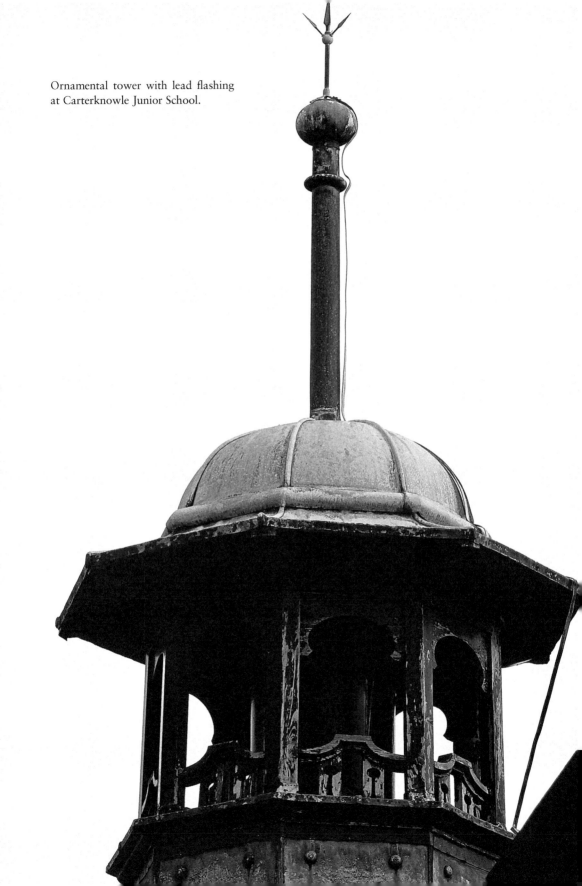

Ornamental tower with lead flashing
at Carterknowle Junior School.

east gable facing Bannerdale Road has a stone-mullioned four-light cross casement with a single shouldered, gabled bell turret. On either side are two segment-arched leaded dormers with transomed glazing-bar windows. These are complex and complicated buildings, beyond the scope of this short account. However, the Grade II-listed Carterknowle building has importance as a complete example of work by E. E. Holmes & A. F. Watson from the period 1893–1906, when they designed several schools for the Sheffield School Board.

Despite the tremendous output of sometimes inspiring, and sometimes intimidating buildings, not everyone was impressed. Local MP David Chadwick was invited to open Park School in 1875, and questioned how the School Board managed to justify the spending of around £100,000 in building fourteen or fifteen schools – each as substantial as a castle.

32. Firth Hall, Sheffield University, Western Bank

At the heart of Sheffield University is the red-brick building of Firth Hall, designed by E. M. Gibbs and constructed from 1903 to 1905. The court with its quadrangle behind – a nod to the Oxbridge colleges – is built of Accrington brick with large mullioned and

Below, opposite and overleaf: Firth Hall.

transomed windows, an oriel in the centre, and grand rooms inside. The quadrangle and the adjacent buildings have a strong Oxbridge and old university feel. The building was inaugurated by Edward VII and Queen Alexandra in 1905, the same year that Sheffield University was granted its royal charter and officially became a university.

Firth Hall is named after Sheffield steel manufacturer Mark Firth, who played a key role in the University of Sheffield's early development. The building originally housed the university's Arts, Science and Medicine Departments. The central room on the first floor over the main entrance is called Firth Hall, and has a fine scissor-braced oak roof with pendants hanging from the trusses. Much of this is now concealed behind a suspended ceiling. There is a large war memorial that was created in 1926 by H. St John Harrison; it is in the form of a canopied shrine containing an illuminated alabaster bowl to throw light on the names of the fallen in the First World War.

Most of the building is now given over to university administrative functions, and three rooms have ornate plaster ceilings. In what was formerly the professors' common room, (those halcyon days!), the ornamentation is genuinely seventeenth century and was a gift from the Duke of Norfolk. The chancellor's room dates from 1905.

At the western end of the building and overlooking Weston Park is the former library, an octagonal structure of 1909 by Gibbs. This distinctive building is somewhat like a chapter house and again a throwback to the older university colleges on which this vision was modelled.

33. Mayfair Court, Former Common Lodging House, West Bar

This large dramatic building was designed and built by Roger Truelove in 1912; his father, Alderman Truelove, paid the cost. The undertaking was intended to provide decent accommodation for the poor workers. The idea was to create hostel provision that replaced the often poor and insanitary lodgings for rent from private landlords of the time. The development included public rooms and additional social facilities.

Mayfair Court.

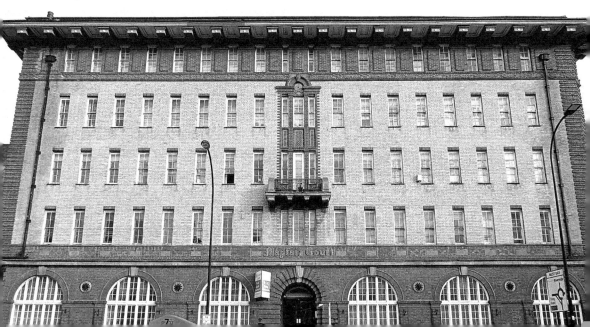

In terms of its design as well as its purpose, the building is particularly interesting for its time. The design on this tall, thin, impressive building includes contrasting yellow and red brick, with a central balcony and details in rusticated brick quoins. The public rooms were located on the lower floors and lit by large, segmental arched windows – still a striking feature of the building today. The premises had four floors of bedrooms on the upper levels, which had narrow segmented windows.

The property is now divided into modern private rentals of the type that are increasingly popular for urban living. Interestingly, though, with this now renovated, refurbished and upmarket, we still have too much shabby private property to let and poorer people in dire need of fit-for-purpose accommodation.

34. Former *Sheffield Telegraph* and *Star* Building, High Street

Formerly known as Kemsley House (named after Gomer Berry, 1st Viscount Kemsley, the newspaper proprietor), this Grade II-listed building was constructed in 1916 to a design by Gibbs, Flockton & Teather as offices for the *Sheffield Daily Telegraph* and *Star* newspapers. Restored in 1985, it now offices and shops. This rather striking feature of Sheffield High Street is in the baroque revival style with a faience front now painted. It has a high tower

Former *Telegraph* and *Star* building.

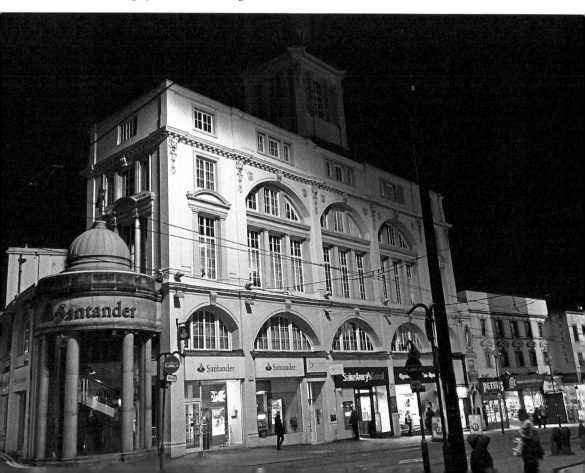

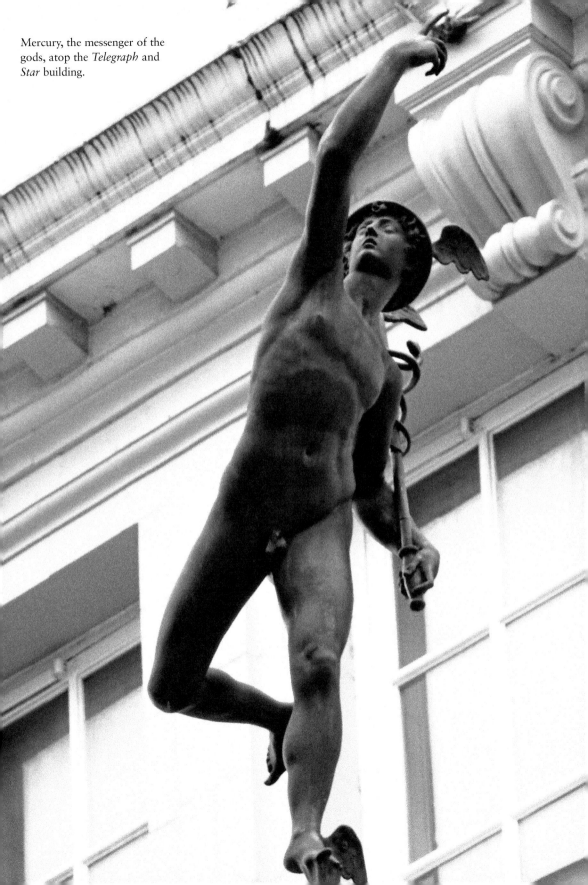

Mercury, the messenger of the gods, atop the *Telegraph* and *Star* building.

with a four-sided, domed lead roof and concave-sided lead roofs below, along with a clock face on each side. The exterior has two main storeys, with attics above and windows that are mainly metal-framed glazing bar casements, and a main entrance with its own dome at the end of York Street. The central block first floor is divided by pilasters with festoons under a dentilled cornice with breaks and three triple-light windows divided by Doric columns under heavily moulded transoms. Above these main feature windows are segment-headed Diocletian windows with shaped keystones and roundels in the spandrels. The narrower end bays have single windows plus moulded lintels and cornices, over which are single smaller windows with moulded surrounds. The ground floor has five large segment-arched main openings with scroll keystones under a moulded cornice.

35. Abbeydale Picture Palace (Abbeydale Cinema), Abbeydale Road

This iconic building in the Abbeydale Road and the Sheffield Antiques Quarter has seen better days. This is the best preserved of Sheffield's surviving out-of-town cinemas, most of which have gone the route of the bingo hall to demolition. Abbeydale is currently going through yet another phase of refurbishment and renewal as it seeks its long-term identity. The cinema was built in 1920 by Dixon & Stienlet and included a flytower to allow its

Abbeydale Picture Palace.

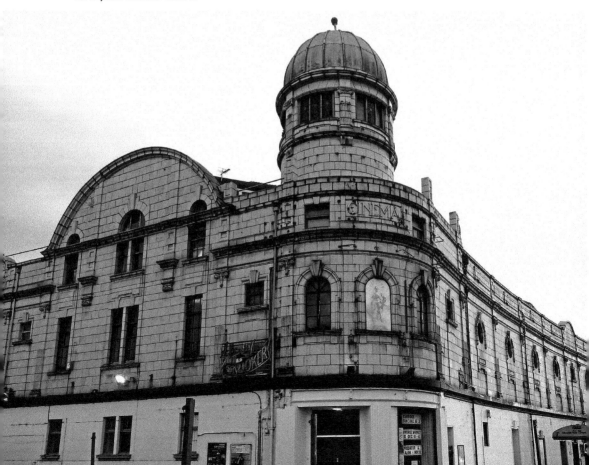

use as a theatre as well as a picture palace. The building also included a ballroom and a billiard hall, which helped its later emergence as a snooker venue. The structure has a steel frame with a façade of white faience and impressive – if rather crude – decorations. The hall has a row of circular windows with a splendid domed turret over the entrance. Much of the interior is intact, and in its pomp this was a sumptuous example of an old-fashioned picture palace with heavy velvet wallpaper, deep seats, and the rest. For many local people this was the venue to visit rather than heading down town to the city centre cinemas to see such greats as the *Sound of Music*, *Ben Hur*, or *Zulu*; they seemed so much more authentic in the luxuriant surroundings of a suburban palace.

36. The City Hall

Until the advent of the former Don Valley Stadium and the Sheffield Arena, the City Hall was the premier local venue for concerts and events, from pop and heavy metal to opera and classical. Even today the City Hall is a most impressive monumental structure. It was designed by E. Vincent Harris and built between 1928 and 1932, and is regarded as one of the best civic buildings of the interwar period. The corporate need for a large building capable of hosting concerts, lectures and meetings in Sheffield had long been recognised. However, since 1873, the New Albert Hall on the southern side of Barker's Pool had fulfilled the commercial side of this requirement. One result was that the need for a large pubic hall was omitted from the designs for the 'new' Town Hall.

At one point it seemed that the council might simply purchase the New Albert Hall, but this idea fell from favour as the idea of building a grand civic 'City Hall' as a suitable memorial to the First World War gathered strength. Harris's design in the classic revival style

City Hall.

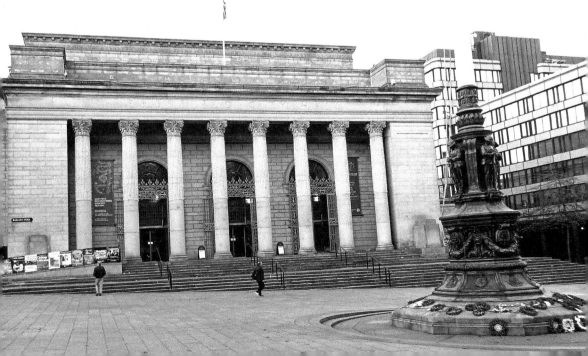

won the competition, which stated that the city desired a 'simple and dignified design'. The implementation was plagued by public finance problems during the depression years, and the eventual cost was £443,000 for a large 2,300-seat theatre and a smaller 550-seat memorial hall. Later inclusions in the brief were the ballroom, bars, and other function rooms in the basement.

The result was a massive exterior that dominates the square outside – Barker's Pool – and a richly ornate but functional interior capable of delivering a diversity of events and activities. The main entrance is reached up a wide sweep of stone steps and the simple but compact stone blocks of the frontage are set-off against the huge stone pillars. The structure is reinforced concrete and brick with a facing of Darley Dale sandstone. The two concrete supporting beams for the roof were, at the time, some of the largest ever made. They required 25 tons of locally made steel reinforcing bars.

In the early 2000s the building received a full upgrade and restoration, which maintains its significance and importance as a venue for Sheffield and the wider region.

37. Graves Art Gallery and Central Library

The white stone building of the Graves Art Gallery and Central Library dominates an area around Tudor Square in Sheffield centre. Built between 1929 and 1934, this grand, dignified building was designed by W. G. Davies, a monument to city civic pride at the time but now the

Graves Art Gallery and Central Library.

centre of tension and controversy over its future. The original idea was this created one side of what the Patrick Abercrombie Civic Survey of 1924 suggested as major civic square with law courts, civic offices, and a college. The building was partially financed by businessman philanthropist Alderman John George Graves (1866–1945). Graves made a fortune by setting up one of Britain's first mail-order businesses, and later made generous bequests to the city of Sheffield. In 1929 he donated £30,000 to the city, with the caveat that £20,000 be spent on an art gallery and the remainder on a library. The original vision was that the library and gallery were one side of a newly created large civic square. However, following the end of the Second World War the bigger scheme was abandoned, leaving just the gallery and library as magnificent and imposing buildings, but out of context and fronting the wrong way. The impressive art deco front is only seen close up and from Surrey Street, rather than from a distance as intended.

As the more ambitious project fell away, the concept was never resurrected. Pevsner, writing in 1959, was not impressed about this; he described the location in which the building was now found as 'incomprehensively insignificant'. As he observed, the situation was such that it was impossible to see this major civic building from any substantial perspective.

The steel-framed construction is faced with Portland stone with high Ionic pilasters and a high parapet wall around top-lit library rooms and galleries up to the third floor. Inside, the building is big, bold and well lit, with high-ceilinged reading rooms and tastefully subdued art deco designs.

The third-floor gallery was funded by Graves; without his generosity and vision Sheffield would be a much poorer place today. Graves also donated around 400 paintings – the core of the city's collection.

38. The Arts Tower, Sheffield University, Weston Bank / Bolsover Street

One of the most striking and dominant features of the Sheffield skyline is the recently refurbished Sheffield University Arts Tower. It was built in 1961–65 and opened in 1966. The building was designed by Gollins, Melvin, Ward & Partners, who were the winners of a competition that had begun in the early 1950s. The top floor of twenty storeys rises 78 metres (or 256 feet), and the completed structure was formally opened by the Queen Mother in June 1966.

A bridge at first-floor level connects the tower to the modern library building adjacent; this was opened as the Main Library in 1959. The structure is concrete-framed with an open ground floor and sixteen columns supporting a concrete slab of around 1.5 metres thick. The whole affair is supported by the columns and the central core of reinforced concrete that contains the lifts and associated services. An interesting feature of the building is the mix of two large conventional lifts and a constantly circulating paternoster lift. This has been a source of both amusement and annoyance ever since it opened, with students in the old days trying to stay aboard to see what happens when you get to the top and novices struggling to judge the exact point in time to hop aboard or to step off. The former leads to the triggering of a fail-safe system to stop the lift and leaves a good few of its passengers stranded between floors – feet visible from the floor below and head and shoulders from the floor above. The grand entrance to this elevated building is a landscaping problem because of the winds and eddies associated with tall structures in exposed locations.

The Grade II*-listed Arts Tower in its high position above the older parts of the city remains a landmark structure and highly significant statement by the University of Sheffield. English

Sheffield University Arts Tower.

Heritage experts have described the Arts Tower as the 'City's finest post-war building and said to be the tallest university building in the country', and it recently featured in a major exhibition by Historic England, called 'Brutal and Beautiful: Celebrating Modern Architecture'.

39. Park Hill High-Rise and Hyde Park

Another tremendously controversial Sheffield building is the Park Hill complex, and formerly the Hyde Park development close by. The controversy was over the original concept of the 'streets in the sky' mass housing, described as both brutalist and modernist and designed by Lynn and Ivor Smith for J. L. Womersley in 1953. The scheme to help rehouse people from slum clearance areas in the inner city got the go-ahead in 1955, with work commencing in 1957. The completion of four blocks ranging in height from four to fourteen storeys was in 1961. The topographic situation is significant since the mass roofline remains level, and all but the top deck reach the ground at some point. The flats dominate the skyline beyond the Midland Railway station, as viewed from the city centre. At the time, brutalism was described as an ethic rather than an aesthetic, and eventually the Park Hill development was recognised as being of international significance in the development of residential architecture. This recognition was through designation in 1998 when the complex was given status as Grade II-listed building as a modernist iconic design.

Writing in 1967, Pevsner was less than convinced. While he admitted the cleverness of the scheme, he was unconvinced of the soundness of the concept itself. He felt that 'there can alas be no doubt that such a vast scheme of closely set high blocks of flats will be a slum in half a century or less'. Sadly, by the 1980s this was exactly the case, and large parts of the Hyde Park complex were demolished.

Park Hill and Hyde Park complex.

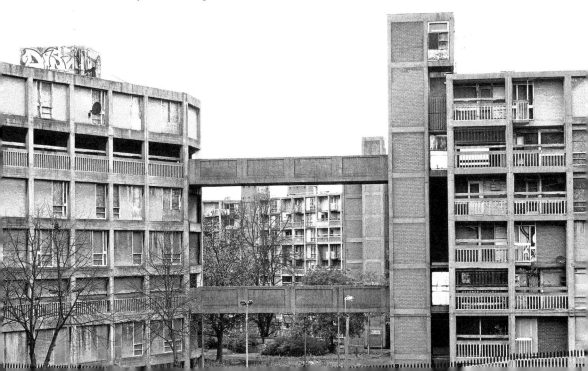

Much has be said and written about the Sheffield high-rise developments. The Park Hill complex had a major refurbishment on the back of the 1991 World Student Games to provide the Student Games Village. Since then there has been a long-running programme of upgrading and improvements to amenities, such as landscaping. The merits of the streets in the sky approach to mass-housing remain to be debated, but the questions asked by many local people for the designers, planners and heritage designators remain: 'how many of them ever lived in such a place?'

40. Debenhams, The Moor/Charter Row

Today the Debenhams store dominates the top of The Moor in Sheffield city centre, an area now going through a major regeneration programme. This big department store began life in the 1960s as Pauldens Ltd. Sheffield was then famed for its independent stores, though Atkinsons is the only one remaining today. Indeed, established 145 years ago, the latter is The Moor's (and probably Sheffield's) longest-running independent department store. Other businesses included Robert Brothers, Walshs, Cole Brothers, Pauldens, Cockaynes and the famous toy shop Redgates. Atkinsons, and now Debenhams, were central to the initiative called 'Moor the Merrier', a campaign that triggered an annual festival to focus

Debenhams.

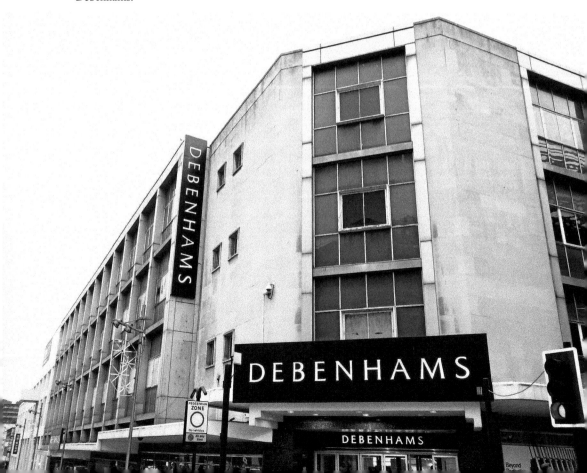

attention on the pedestrianised The Moor. This was probably one development that helped lead the way to the current work to rejuvenate a problem area for retail. In the early 1980s the top of The Moor even gained its own bandstand.

Pauldens was not itself a Sheffield-based firm, but had a big store in Newcastle; the original was in Manchester. Pauldens of Manchester had been established in the 1860s but was bought up by Debenhams in 1928. It was then rebuilt in 1930 but destroyed by fire in 1957 and the new building opened at Drill Hall in 1957. Relocated to the Rylands Warehouse building in 1959, it was renamed and rebranded as Debenhams 1973. In Sheffield, a Pauldens was opened by Debenhams as a branch of Pauldens of Manchester, but in 1973 it was renamed Debenhams. The Debenhams Group now occupies the most sites of any of traditional department store group in the UK, mostly under the parent company name.

The 'modern' 1960s/1970s building fronts both The Moor and Charter Row and is a major feature from both of these approaches. It is a multistorey building with a steel frame and concrete structure of limited architectural merit. However, over the years the store has kept up with the times and adapted to changing trends and styles to remain hugely successful. This is despite competition from its larger namesake at the Meadowhall Shopping Centre.

41. Electricity Substation, Moore Street

This concrete monstrosity, constructed for the CEGB, has been described as an outstanding expression of the brutalist ethos. It was designed and built by Jefferson Sheard & Partners from 1965 to 1968. The whole creation is massive and uncompromising and for me imposes itself without any sympathy to the surrounding environment or community. I can

Electricity Substation.

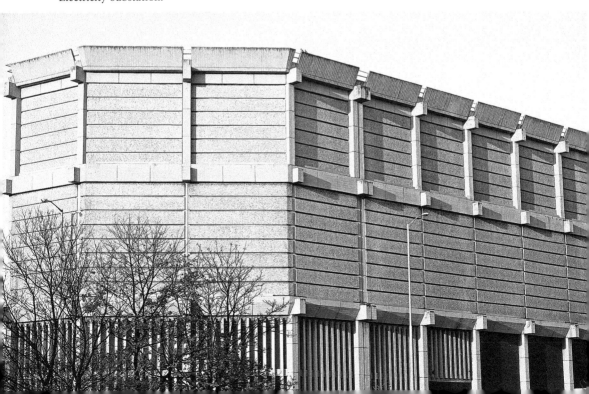

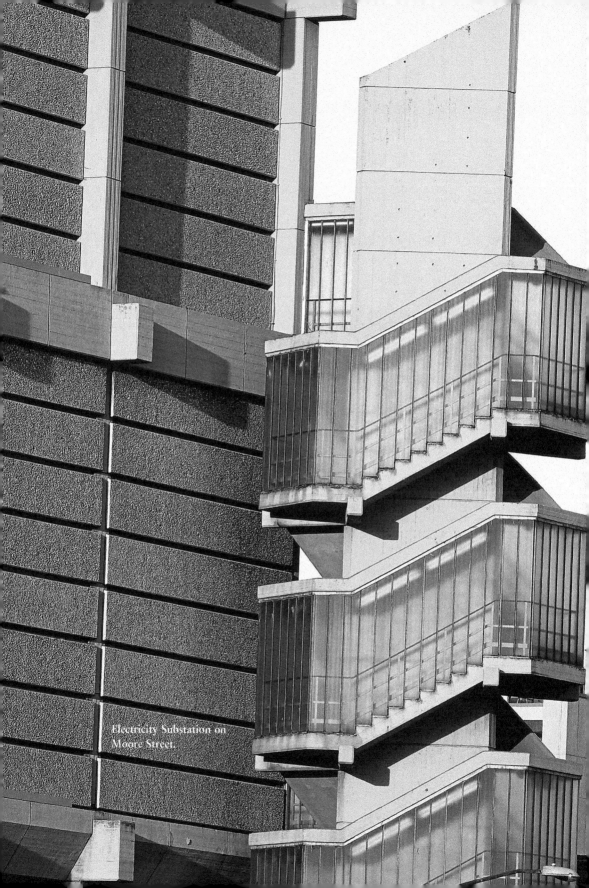

Electricity Substation on
Moore Street.

understand that aficionados of modern architecture may take a different view, but this is a building that, personally, has little merit beyond basic functionality. It has been described as being loathed by generations of Sheffielders, but having a firm expression of its purpose appropriate to its position on the inner ring road. This may be so, but surely a prominent location where it is visible to many passers-by, and a dominant feature for communities living in and around the area should delivery aesthetic alongside function. Around the same time as this substation was built, an equally – or perhaps even more – horrific concrete residential development was constructed a little up the hill towards West Street. Thankfully this was demolished in the 1980s, as I recall, with serious asbestos problems too.

42. The Crucible Theatre, Arundel Gate

Arguably Sheffield's most well-known building because of its association with the World Snooker Championships, the Crucible Theatre was designed and built by Renton Howard Wood Associates between 1969 and 1971. The Crucible Theatre was built by M. J. Gleeson and opened in 1971, when it replaced the Playhouse Repertory theatre in Townhead Street. The ever-popular Sheffield Repertory Co. presented successions of classics over the years, based on fortnightly production-turnaround and guaranteed to be packed audiences. Subscribing regulars booked the same seat throughout the season. The plays frequently starred upcoming actors like Paul Eddington, Patrick McGoohan and Nigel Hawthorne, who soon went on to become household names.

The Crucible and the Lyceum.

In 1967, Colin George, founding artistic director of the Crucible, recommended a thrust stage inspired by classically inspired stages created by Sir Tyrone Guthrie. The building houses two main auditoriums of 1,000 seats, and the smaller Studio Theatre for 400 people. The objective of the new theatre was to replace the very old fashioned, but fondly regarded, Sheffield Playhouse, and to create a modern theatre with intimacy, flexibility and immediacy, and even harking back to the classical origins of the stage. This approach was not wholly welcomed at the time by traditionally conservative Sheffield theatregoers, but over time they've been won round. The Studio Theatre provides a more intimate venue for chamber music, other smaller concerts or productions, and generally more modest productions.

Fronting onto Tudor Square, the modern, simple (but perhaps harshly angular) style of the external building jarred with its setting and was not universally welcomed, along with the Town Hall 'Egg-box'. Over time opinions have mellowed and the Crucible has become a part of Sheffield's identity. It is today Sheffield's most famous building because it hosts the annual World Snooker Championships and, as such, the venue is known throughout the world. It is a great ambassadorial event and a setting for the city of Sheffield; its importance is on a par with steel and cutlery.

43. The Royal Hallamshire Hospital, Glossop Road

One of Sheffield's two main general hospitals, the Royal Hallamshire is not a great asset to the city's architectural heritage and some authorities consider it detrimental to what was previously a pleasant residential suburb. Located in the West End, facing Glossop Road, it is close to the University of Sheffield's main campus and to the Collegiate Crescent campus of Sheffield Hallam University. The hospital is part of the Sheffield Teaching Hospitals NHS Foundation Trust and is located close to the Charles Clifford Dental Hospital, Weston Park Hospital, and the Sheffield Children's Hospital.

The main building was designed by Adams, Holden & Pearson, who won a competition in 1940. However, only the concept of the tall 'slab' tower with the lower front pediment survived to be built in 1978, when the hospital was opened by HRH Prince Charles. Low-rise outpatient buildings were constructed in the 1950s and the 1960s. The main hospital is T-shaped with three main interlinked buildings, the most significant being the massive monolith of a twenty-one-storey concrete structure. This is now the third tallest building in the city, following St Paul's Tower and the University Arts Tower. However, the prime position makes it visible from all across the south of Sheffield, making it a very significant landmark.

The Hallamshire has twelve basement operating theatres and five more on the ground floor. For such a large public building with many visitors, access becomes an issue; it is served by three main public lift shafts, each of two elevators, and further provision for staff and services. The upper floors have dedicated wards for Intensive Care Unit. The middle floors have general and specialist wards – most with front-facing windows in shallow V-shaped bay designs. In the 1970s, when the building was constructed as a huge concrete frame and before infilling of windows and structural panels, the Hallamshire had a unique claim to fame. With its tall structure, open location and high location on the south-facing hillside, the wind blew through the gaps to reverberate like a giant mouth organ – the largest in the world. Sheffield always boasts the biggest and best.

The Royal Hallamshire Hospital.

44. The Manpower Services Commission Building, Moorfoot

Dominating the bottom of The Moor at Moorfoot, the Manpower Services Commission building is a striking red-brick construction, which was completed in 1978 for the government's Property Services Agency. This is a seemingly vast building of stepped levels and has a major impact on this somewhat troubled part of the city centre. Hopefully the various new initiatives will finally bring some lasting coherence to what was once a thriving part of Sheffield. To be fair, the Moorfoot area has never fully recovered from the lasting effects of direct hits during the Blitz. The MSC building has been joined in the last decade by some smart residential blocks, office tower blocks and a major hotel; however, it seems to be awaiting the completion of the major regeneration projects along The Moor itself.

The building is based around east, west and north wings, and the whole thing is something like a large pyramid. The original features as a government departmental building, which included a staff restaurant and bar on Floor 2, with a full-sized squash court in the basement.

Construction of the building across effectively severed the traditional access to The Moor from London Road. So, to satisfy planning conditions, Moorfoot was designed to allow pedestrian access 'through' the building. The pedestrian walkway began with an elevated ramp near the corner of Young Street and South Lane, before proceeding via a tunnel through the building (including a section with a glazed roof as the route crossed the base of an open area in the east wing). The walkway exited the building above the car

The Manpower Services Commission building.

park and used sloping ramps to bring the route back to ground level on The Moor, near the entrance to the building. The route was dependent on the completion of further planned development (where the Premier Inn hotel is currently located), but as this did not take place the route was never completed or opened to the public.

Now called the Moorfoot building, it was purchased by Sheffield City Council in the late 2000s, with the government departments as sitting tenants pending their relocation. In 2010, the British government vacated the property and were replaced by Sheffield City Council departments. Plans to demolish the site have been changed to a major overhaul.

45. Meadowhall Shopping Centre, Meadowhall Way

Situated close to the M1 motorway, Meadowhall shopping centre was the biggest USA-style shopping mall in Europe for a while. It is a hugely influential building since it is the most visible and recognisable structure in Sheffield – both for many visitors and millions of travellers per month who drive past on the M1. While not everyone's favourite place or concept, there is little doubt of the impacts – good and bad – of Meadowhall on Sheffield and the region. On the one hand, the development of Meadowhall and the associated economic resurgence of the Lower Don Valley sucked the lifeblood from

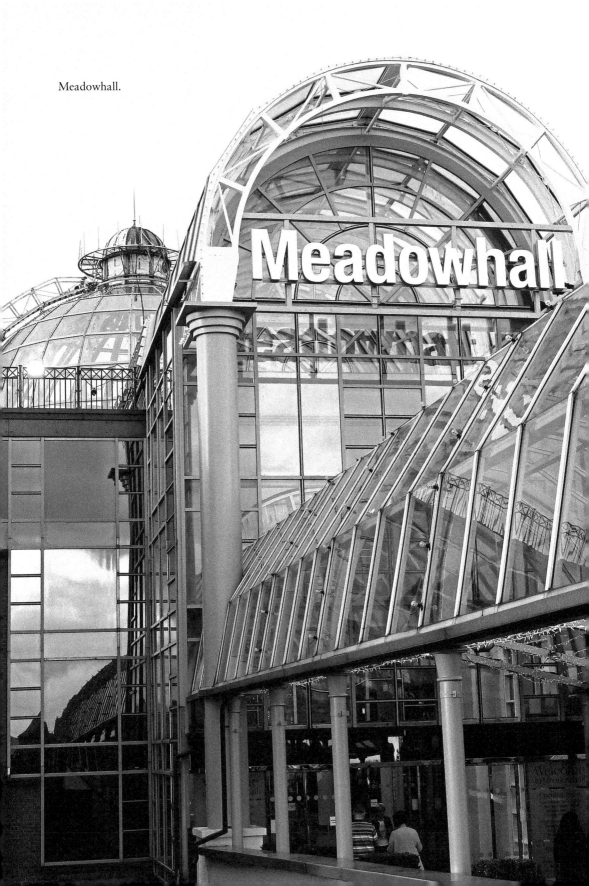

Meadowhall.

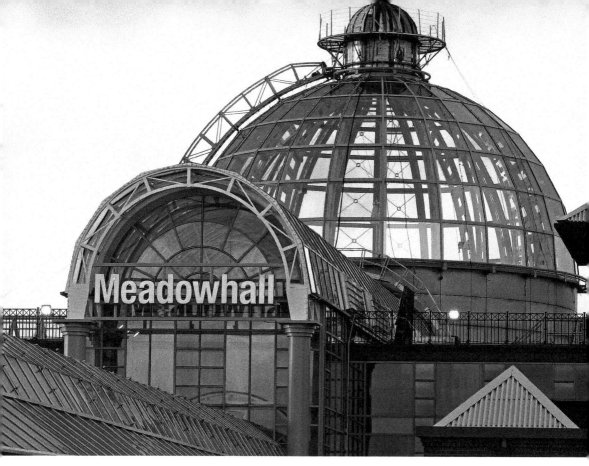

Meadowhall.

Sheffield city centre. On the other hand, Meadowhall has been enormously influential in drawing people, money and investment to the region.

The development was the brainchild of Yorkshire multimillionaire Paul Sykes, and supported by – the unrelated – Hugh Sykes, Chairman of the Sheffield Development Corporation. The scheme turned the largely derelict industrial land into retail and entertainment facilities to create what is now the eighth-largest shopping centre in Britain; and with current expansion plans it will move back up the table. In its first year of opening the centre attracted 19.8 million visitors, a figure that has since risen to around 30 million visitors per annum.

Designed by Chapman Taylor Partners and built by Bovis, the centre opened on 4 September 1990 with 280 stores and other facilities in a floor area of 139,355 square metres. Its green-clad roofs and glazed domes have become an instantly recognisable feature that dominates the Lower Don Valley. The structure radiates out from a main central dome with three top-lit galleried malls in an American-style design. A major feature is the 2,000-seat food mall, which was apparently based on the Plaza de los Naranjas in Marbella as a 'typical Spanish village square'.

While Meadowhall and the nearby developments had a colossal impact on Sheffield city centre and nearby Rotherham town centre too, in the former case the result has been a renaissance of its own. Sheffield has responded and, twenty years on, is much improved and in much better heart.

46. The Owen Building, Sheffield Hallam University, Pond Street

Sheffield Hallam University can trace its lineage back to the Sheffield School of Design in 1843, which changed to the Sheffield School of Art in 1850, and was in rented property on Glossop Road. The City of Sheffield Training College (later renamed Sheffield City College of Education) was then established on Collegiate Crescent in 1905. The Sheffield College of Technology came about through the 1944 Education Act and the duties of provision thus placed on the local education authority.

With numerous other transformations, establishments and mergers, the Owen building was constructed off Pond Street, and in 1969 the School of Art merged with the city's College of Technology to form Sheffield Polytechnic. Then, in 1976, the polytechnic subsumed teacher training colleges at Totley Hall and the City College at Collegiate to form Sheffield City Polytechnic, which in 1992 became Sheffield Hallam University. This final step meant the university had its own charter and thus the right to award its own degrees.

The Pond Street city centre development was designed by Gollins, Melvin, Ward & Partners, and built between 1953 and 1968. The Owen building, at the heart of the campus, is built in a functional 1960s design. It has since been modernised and comprehensively renovated with an atrium linking it to three adjacent buildings. The most significant

Owen Building, Sheffield Hallam University.

and innovative phase of redevelopment of the 1960s buildings was the linking of the twelve-storey Owen building to the Surrey and Norfolk buildings by the Atrium. This massive metal-framed glazed structure forms a prominent core for the university, with entrances to level 5 from the top of Howard Street (Hallam Square) and the city centre, and at levels 1 or 2 from the Pond Street and the Transport Interchange area. The design was by the Bond Bryan Partnership with the intention of providing a new and clearly identifiable heart that unified the previously fragmented city campus. This incorporates adjacent zones such as the Harmer building, the Howard Suite and the link to the Adsetts Learning Centre.

Other works have been ongoing, with new covered entrances to level 5 (the main level) and refurbishments or new builds occurring around the city campus area.

47. The National Centre for Popular Music aka Sheffield Hallam University Students' Union Building

The National Centre for Popular Music was a museum in Sheffield for contemporary music and culture, underpinned by a £15-million project with core support from the National Lottery. The centre was a commercial disaster. It opened on 1 March 1999 and despite a £2 million relaunch, closed for good in June 2000. It had been forecast to attract 400,000 or more visitors

The National Centre for Popular Music.

a year, but after seven months had achieved only 104,000 people. The building's owners, Music Heritage Ltd, went into receivership on 18 October 1999 with PricewaterhouseCoopers called in to administer the day-to-day operations and nearly eighty staff.

For a short while from July 2001 it became a live music venue and was then taken on by Sheffield Hallam University from September 2003. The university purchased the building from the Regional Development Agency, Yorkshire Forward, for £1.85 million in February 2003 to provide a new home for the Hallam Students' Union. For visitors to Sheffield and especially to the Cultural Industries Quarter, 'the Drum Kit' as it soon became known is a most intriguing building. Inspired in part by a Sheffield Hallam University student idea, it was built to a design by Branson Coates as a home for the ill-fated short-lived National Centre for Popular Music. The concept was based on a kit of four drums with stainless steel cladding set over steel ribs – around thirty for each 'drum'. The four units are joined by a tubular steel cross, illuminated by a glass roof and supported by a further steel cross. The drums topped with rotating ventilation shafts are apparently based on the nozzles of shaving foam dispensers. The building has basements and two further floors, and was designed as an experiential space to discover popular music, but very different from the rock and pop memorabilia-type exhibitions elsewhere that have generally proved very popular. Opened with a rooftop concert by an obscure heavy metal band from Chesterfield, the centre soon failed to pay its way. However, as Sheffield Hallam University's Students' Union, the building has proved a very successful space and provides a piece of interesting 'pop' architecture in Sheffield centre.

48. The Millennium Galleries and Winter Gardens, Arundel Street

As Sheffield city centre endeavoured to recover and compete more effectively with out-of-town shopping at Meadowhall, various ideas and schemes were tested – the 'Heart of the City' project was one outcome. The Millennium Galleries, Winter Gardens and the new Peace Gardens have been a dramatic success in terms of linking the walkway up from the Midland station and the Transport Interchange, and into the main city centre. Furthermore, encouraged by the numbers of people associated with the university's presence and visitors to conferences, etc, a street café culture has been developed. This is a far cry from the unwelcoming and confused city of thirty years ago. The Millennium Galleries provide one of the main features to greet visitors arriving in the city, and it is a seamless step through the Galleries into the Winter Gardens and beyond.

Both buildings were designed by Pringle Richards Sharratt in 1995, with the Galleries completed in 2001 and the Winter Gardens in 2002. The Millennium Galleries building is dramatic, if understated, and provides both a major exhibition space and the permanent home for the nationally important Ruskin Collection. John Ruskin had a long and deep attachment to Sheffield and founded the Guild of St George, which still thrives today. The galleries and shops are on the first floor with food and services on the ground floor. The external view of the Millennium Galleries is from Arundel Gate and shows off the roof of lateral barrel vaults and the white concrete columns and beams.

Visitors pass up and through the Galleries and enter the Winter Gardens, which has a high curved roof of glass and supporting arches; twenty-one parabolic, curved strips of larchwood provide a framework to support around 2,000 square metres of glass.

ALGOMECH
FESTIVAL

08.11 – 12.11

RAVILIOUS &CO
THE PATTERN OF FRIENDSHIP

English Artist Designers
1922 to 1942

7 Oct 2017–
7 Jan 2018

Free Exhibition
Please Donate

museums.sheffield.org.uk

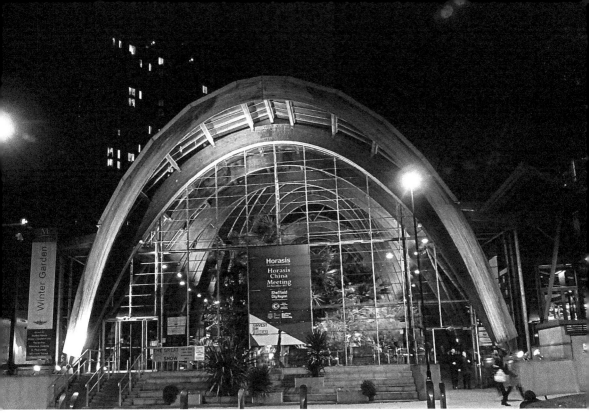

Above: Millennium Galleries and Winter Gardens.

Opposite: The Millennium Gallery from Arundel Gate.

The structure is sufficiently tall to allow planted trees such as Norfolk Island pine, eucalyptus, and other exotics such as palms to flourish and to grow to maturity. The space has a light, airy atmosphere and is used as an informal meeting place, a connecting route through the heart of the city, and for formal events and occasions.

49. The Cheese Grater, Charles Street

Not everyone likes it, but in 2013 its car park was named the third coolest car park in the world, beaten only by ones in France and the USA. Designed by architects Allies and Morrison, the competition judges stated that the design of the Cheese Grater turned a 'traditional car park space into a visually striking building. The inaugural awards were created to celebrate the creativity and design in buildings 'often perceived to be dull and dreary', according to the organisers, *FX Design*. David Greenbrown, founder of an airport parking business and assistant editor of *FX Design*, said that choosing a winner for the inaugural World's Coolest Car Park awards was not an easy decision. He said that, having started with car parks from all over the globe, they had found many awe-inspiring parking buildings worthy of praise. In terms of the Cheese Grater, he noted that at first glance the Sheffield Charles Street Car Park appeared to be a chic contemporary apartment block, but it was in fact a sleek and stylish car-parking building. The 550-space multistorey block has exterior panels angled in different directions to give the appearance of ... a cheese grater.

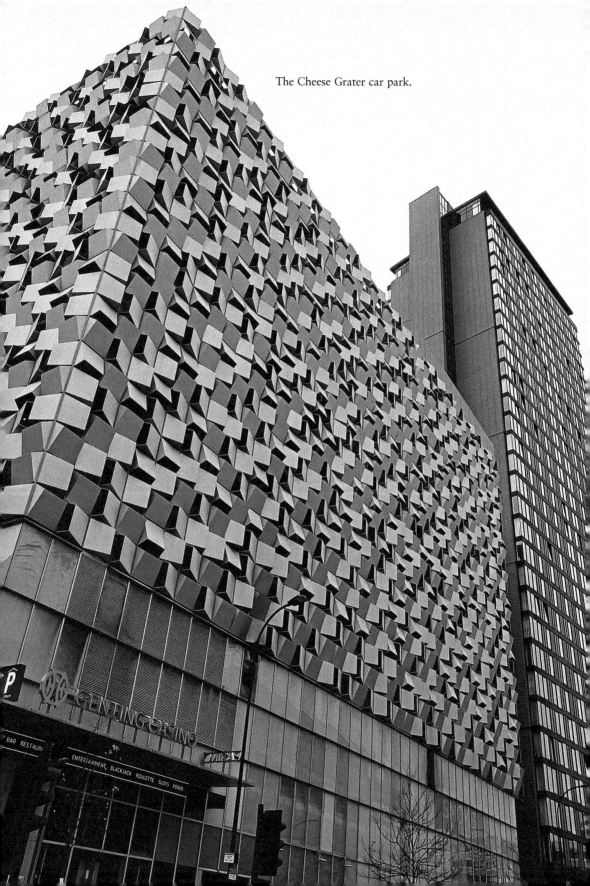

The Cheese Grater car park.

The Cheese Grater.

5c. St Paul's Tower, Arundel Gate

It was suggested in the 1990s that a significant city centre needed a tall building. The one that Sheffield came up with was St Paul's Tower (also called the City Lofts Tower or the Conran Tower) and St Paul's View. This tower block residential development was opened in April 2011 with a thirty-two-storey building called St Paul's Tower. This is mostly faced with glass and includes a nine-storey block – St Paul's View – of glass, sandstone, and bronze. The two components join at the base, with a floor of retail space and a roof terrace over the retail building. St Paul's fronts two newly created public squares: Millennium Square and St Paul's Place, both important in the emerging bar and restaurant district. The towers and associated squares were part of the St Paul's Place development with three other office blocks, a multistorey car park, and casino. Facing Hallam Square and around a quarter of a mile from the Midland station, this is a core part of the wider 'Heart of the City' regeneration project around Sheffield Town Hall.

On completion in August 2010, at 101 metres (or 331 feet) this building became Sheffield's tallest, overtaking the Arts Tower by 23 metres (or 75 feet). However, because the Arts Tower is 'up the hill' by around 45 metres, its roof still stands proud of St Paul's by around 22 metres. The development provides 316 one- and two-bedroom private apartments for city centre living, alongside the other uses already described. The project's

St Paul's Tower.

design is described as conservatively modern to complement the surrounding buildings such as the adjacent Grade I-listed Town Hall and the modern Winter Garden and Millennium Gallery.

With planning consent given in October 2005, the work should have finished by late 2008. However, global financial collapse meant the parent development company went into liquidation, and the Sheffield residential property market had also been adversely affected by the global meltdown. There was also an issue of the planned exterior cladding having changed to save money, which raised further concerns. With modified plans submitted, losing a planned spire and thickening window frames, the project was completed in 2011.

Acknowledgements

I wish to thank the publishers for their support and endless patience, and numerous colleagues for their insight and inspiration over the years. Sheffield Industrial Museums Trust is thanked for access to photograph Abbydele Industrial Hamlet.

Sources and Further Reading

Bunker, B., *Portrait of Sheffield* (London, Robert Hale, 1972).

Harman R., and Minnis, J., *Pevsner Architectural Guides: Sheffield* (New Haven & London, Yale University Press, 2004).

Hey D., *A History of Sheffield* (Lancaster Carnegie Publishing Ltd, 1998).

Pawson & Brailsford, *Illustrated Guide to Sheffield* (Sheffield, Pawson & Brailsford, 1862).

Pevsner, N., *The Buildings of England: Yorkshire – The West Riding* (London, Penguin Books, 1959).

Rotherham, I. D., *Lost Sheffield in Colour* (Amberley Publishing, Stroud, 2013).

Vickers, J .E., *The Odd, Amusing and Unusual in Sheffield* (Sheffield, J. Edward Vickers, undated).

Vickers, J. E., *The Old & Historical Buildings of Sheffield* (Sheffield, JEV Publications, 1968).

Vickers, J. E., *Old Sheffield-: Its Streets, People and Stories* (Sheffield, JEV Publications, 1970).

Walton, M., *Sheffield: Its Story and Its Achievements* (Sheffield, Sheffield Telegraph & Star Limited, 1948).

About the Author

Ian Rotherham is Professor of Environmental Geography and Reader in Tourism & Environmental Change at Sheffield Hallam University. He is an environmental historian and a worldwide authority on ecology, landscape history and on tourism and leisure. Born in Sheffield, Ian established and directed Sheffield City Council's Ecology Service within the City Museums Department, writes for the *Sheffield Star*, *Sheffield Telegraph*, and the *Yorkshire Post* newspapers, and has a regular phone-in on BBC Radio Sheffield. Ian is an ambassador for Sheffield and the region and has written, edited and published over 500 papers, articles, books and book chapters. He lectures widely to local groups and works closely with conservation organisations and agencies. His recent books include *Lost Sheffield in Colour*, *Lost York in Colour*, *Lost Nottingham in Colour*, *Secret Sheffield*, *Sheffield Pubs*, and several others for Amberley Publishing.